THE LOST ROLLS

THE LOST ROLLS

RON HAVIV

EDITED BY ROBERT PEACOCK

ESSAYS BY
W. M. HUNT
LAUREN WALSH

FOREWORD

What happens if a tree falls in the forest and no one remembers?

Traditionally photographs represent themselves as depictions of the truth. But Ron Haviv's more than 200 lost film rolls were purposely discarded and set aside. He completed the assignments, arrived home, unpacked, and the extra rolls shot on secondary cameras were thrown in the bottom drawer. He never thought much about sorting through them. For more than twenty years the rolls sat until he decided to develop them.

Now he was faced with a unique situation of looking at that material and trying to make some sense of it. Some of the events and people are immediately recognizable—places, sometimes; people, maybe not; and time, even less. There are no GPS coordinates or time-dating APPS to rely on here. This is analog territory. These are rolls that had one or two exposed frames, which survived or were the victims of time, airport x-ray machines, or the accumulation of dust and humidity.

The Lost Rolls is an edit of lucky accidents—surreal with images out of time and from another dimension. But because the maker is consistent—Haviv is an award-winning photojournalist—the talent and sensibility are the same. There is coherence to the vision if not the sequencing. This is an odd montage of images from a singular sensibility.

Collectively the images offer up a review of Haviv's life and travels, from Eastern Europe to Africa, Mexico to the United States. Sometimes we—the photographer and the viewer—recognize the event or the place. There is a dream-like quality to the sequence with one thing telescoping into another. We bump along accepting the journey. And we linger on the individual images.

There is the black-and-white portrait of the sad-eyed mother and child. It reminds the viewer of the others like this, the ones we've seen and the ones we haven't seen, but know are out there. Memory is a slippery business. Do we know these two souls? Even Haviv has no actual memory of the time, place or event for this striking image. Kosovo? Perhaps.

This is a photograph so it must be a capture of some memory. Here is visual evidence of two people without any attendant information. It has a stand-alone purity, because it doesn't reference facts only memories of other things.

We look at this black-and-white photograph of the woman and child and conjure up all those "Migrant Mother" images by Dorothea Lange and other beseeching Eastern European refugees. This is a trope of sorts in humanistic

photography. One of the wandering children in W. Eugene Smith's "Walk to Paradise Garden," who has been scooped up to be held by an unknown, soulful caregiver.

This is also the experience of opening a trunk in your attic and finding photographs of unknown family members spilling out on to the floor. All those histories and those memories, but whose?

Look at the strong image with the red flag. Haviv remembers the event, if not the exact moment. It is a good marker for an important and dynamic period for the photographer. The red flag covering the face of someone and the Soviet-era statue in the background,

Memories are inexact and incomplete. Then we encounter images that may have been a memory, but in this reconsidered context become new.

which both have a lack of specificity that actually enhances the work and strangely enough also gives it a timeless quality. It may have been lost and forgotten, but it is a good strong image and worthy of our attention.

Memories are inexact and incomplete. Then we encounter images that may have been a memory, but in this reconsidered context become new.

The reddish hue of the handcuffed gang in the El Salvador image offers an unintended effect of "rose-colored glasses." The result makes for a theatrical and appropriate memory, a perfect accident. The joined arms are muscular and give the image strength, but it only exists in this contemporary iteration.

In another photograph the corona of light surrounding former New York City Mayor Rudy Giuliani gives him a radiance, which the viewer may or may not agree with politically, but at least it is ironic and new.

The deteriorated film stock for the bandana-wearing protesters actually increases the drama of the image, giving it a rougher, even brutal quality. Survival lies at the very heart of the image. The confusion of nationality gives it an enigmatic edge too.

What other buried treasures are to be found in the rolls of film, of which many yielded results? The whole range of Haviv's film stocks or types are represented: color negatives, color slides, and black and white.

Haviv confessed to a range of feelings when viewing the results, from bemusement to bewilderment. With this chance to revisit stories that he imagined were complete and published, were there any new

insights? Yes and no. Andre Agassi captured at the U.S. Open? He's seen it, and we've seen it. Kosovo and Palestine? These were missed and absolutely worthy.

Found on the earliest lost roll or two is a forgotten exchange with the late and legendary journalist Marie Colvin. There is even a fleeting glimpse of an old girlfriend.

There are also the images of now forgotten people. Who is this? Where? When? No regrets, according to Haviv, except for some missed portraits of displaced people in Kosovo on some 2 1/4 black-and-white film. This experience comes with a satisfying sense of completion.

There are the damaged films with light leaks and moisture creating semi-abstract works like those of contemporary photographer Matthew Brandt. The chemistry has left wholesale changes to the images rendering them colorful and ghostly.

What is this curious Twilight Zone, Mr. Haviv, our photographer, has ventured into? Are these like journals stored carelessly? Then looked at again one day, finding them incomplete, damaged, and out of sequence and offering up a discombobulated history and a skewed look back?

Haviv is not disorganized. He is systematic. These are films he never intended to have processed. The jobs had been shot and delivered, the film had been x-rayed and damaged, or it was personal work he might look at later when he had the time and money to develop the rolls. There was nothing more to do with the material than to put it aside for another day.

That time came thanks to the encouragement of photographer Dan Milnor and Blurb. Haviv has returned to evidence of another time—the era of analog film. There were surprises and gaps with the photographer reimagining the past.

Haviv is a distinctive character. He looks alert. His eyes light up. He trades on his smarts and sometimes by his own admission, dumb luck. He is bright and articulate. He bears witness. Ron says he appreciates, "The responsibility and the privilege of being able to tell people's stories—the idea of helping to affect change."

The Lost Rolls by Ron Haviv give us a welcome reminder of the photographer's talent and skill and somewhat uncanny ability to navigate the world and bring us stories. These are the unexpected, untold tales.

That tree that fell in the forest ... maybe someone did photograph it.

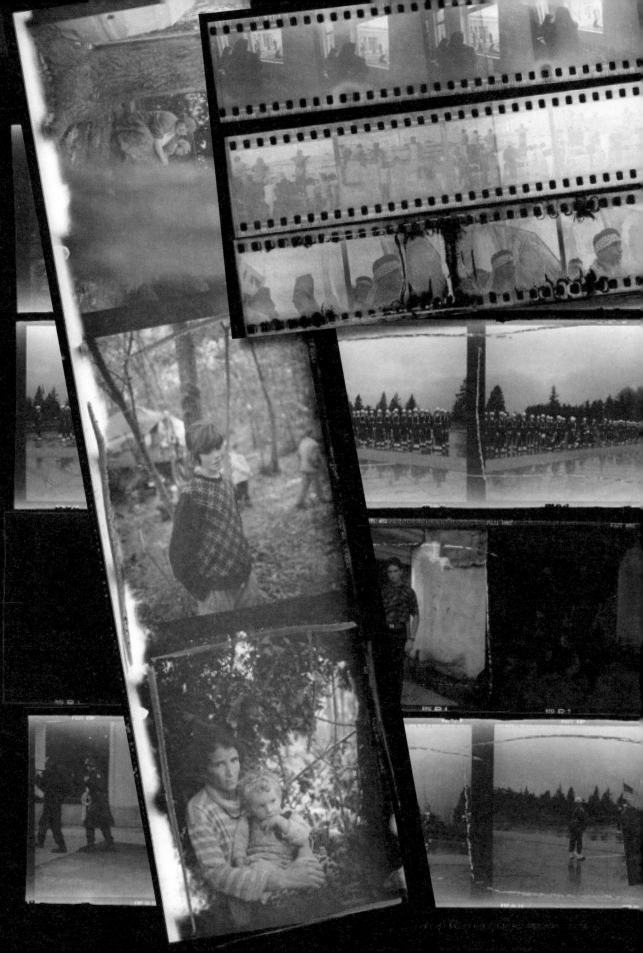

STYLE NO 35 7BXW

Print File
ARCHIVAL PRESERVERS
WWW.PRINTFILE.COM

ASSIGNMENT:

DATE:

THE LOST ROLLS HANJV

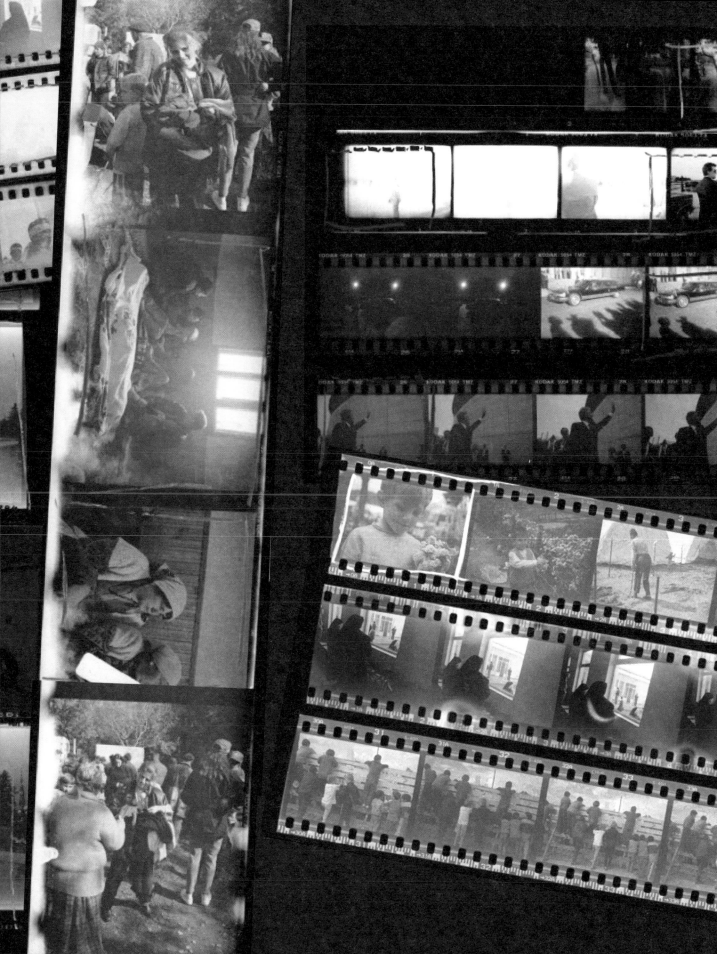

Swimming in the Unreliable Shadow of Memory

"It has been said that 'not he who is ignorant of writing but ignorant of photography will be the illiterate of the future.' But isn't a photographer who can't read his own pictures worth less than an illiterate?"

–Walter Benjamin[1]

The German philosopher and cultural critic Walter Benjamin penned those words in a 1931 essay that reflected on the evolution of photography over the preceding century. His indictment of the photographer "who can't read his own pictures" is a curious one, because it inextricably links the visual with the textual: Seeing and reading are conflated to one act. And while Benjamin presciently takes up the issue of a society dominated by the image (where those "ignorant of photography" are the outliers), his indictment here of the photographer is more problematic, or at the least more complex.

What does it mean to "read" a photograph? In crossing forms—from the visual into the textual—Benjamin has complicated the ability to answer this question. To see an image is to perceive it optically. To read an image is something more. It suggests an understanding of what is pictured, and a grasp of the context in which it was taken. It also implies that the photographer recognizes the visual grammars through which his images will be received, or *read*, by a viewer. So is the photographer who can't read his own image really "worth less than an illiterate"? What happens when the usual grammars he relies on break down? Is the picture then unreadable? Or might it become a new form of photography with its own unique grammar, its own legibility, and its own new narratives to divulge?

Ron Haviv's *The Lost Rolls* is a project that forces these questions to the foreground. Having discovered rolls of undeveloped film, Haviv had the experience of being reacquainted with the past, in some cases decades later, when all the lost rolls were processed in 2015. A selection of those images is reproduced here,

To see an image is to perceive it optically. To read an image is something more. It suggests an understanding of what is pictured, and a grasp of the context in which it was taken.

some of them accompanied by written vignettes, which express the free-flowing thoughts Haviv had in response to seeing each image today—a Rorschach test of sorts. The photos call forth some factual details but also personal anecdotes and pensive reflections; and in at least one case, the Rorschach draws up a blank. "I can try to piece together where I was, but not what I was doing or why I was there," writes Haviv in response to a pair of faded images of beachgoers (images 71 and 72).

This project, situated squarely in the digital era, is an ode to the past—to the analog era, to the time when undeveloped rolls of film might lay buried amidst papers in a desk or orphaned in a kitchen drawer among worn-down pencils, cap-less pens, and dried-out rubber bands. It is an ode to an experience that many of us may have had, in coming across a stray roll of unprocessed Kodak film. It is perhaps also a lament to the passing of that experience, as fewer and fewer photographers (whether professionals, hobbyists, or cell-phone camera users) shoot on film. And this ode to the memory of an analog time past is simultaneously as much about the act of remembering itself. *The Lost Rolls* is a penetrating look at the relationship between photography and memory.

A photograph is an instant, captured visually, and removed from the continuum of time. A memory is rather similar. We can't remember everything we've ever experienced; rather, certain instants, events, or details stand out. We remove them from the continuum of time, and, at least metaphorically, "tuck" them away. Remembrance is the act of revisiting, perhaps even reanimating a past experience at a future point. And often it is visual in nature.

In fact, photography has long been linked with memory. In 1859, Oliver Wendell Holmes called the daguerreotype "the mirror with a memory."[2] By the early twentieth century, the great French writer Marcel Proust wove detailed comparisons into his tome, *Remembrance of Things Past,*[3] referring to "mental photographs," "snapshots of memory," and "that inner darkroom" where we "develop" experiences. Toward the end of the novel, the narrator even laments that too often one's "past is encumbered with innumerable 'negatives' which remain useless because the intelligence has not 'developed' them."[4] Nearly a century later, Haviv plays with this idea, exploring what might have been lost had his negatives never been developed, as well as what is gained in the act of processing them belatedly.

Proust, a quintessential author of memory, investigated "the vast structure of recollection" and is known for his literary portrayals of involuntary (or Proustian) memory, where the remembrance is so crystalline that the rememberer very nearly re-inhabits the past in all its colors, scents, sounds, and textures. But for Proust's narrator those were rare moments. More common are the memories that remind us of past experiences, which we can't revisit in complete detail—because memory of course is fragile, fallible, and pliable. It changes over time and, like long forgotten film stock, it degrades. Sometimes its edges become frayed and the colors bleached—names lost, places forgotten, dates obscured.

As a tangible form that, in ways, acts like a memory, the photograph would thus seem a helpful tool for reminding us of prior occurrences. Likely everyone has had the experience of looking at an image from one's own past and being "taken back" to the event pictured, that is, reminded of aspects or details. The photo helps jog the memories. The Italian writer Italo Calvino knows that we take this for granted. Playing on the duality of photographs as both documents from, and reminders of, the past, he adds a somewhat withering, postmodern spin in his short story "The Adventure of a Photographer":

> When spring comes, the city's inhabitants, by the hundreds of thousands, go out on Sundays with leather cases over their shoulders. And they photograph one another. They come back as happy as hunters with bulging game bags; they spend days waiting, with sweet anxiety, to see the developed pictures.... It is only when they have the photos before their eyes that they seem to take tangible possession of the day they spent, only then that the mountain stream, the movement of the child with his pail, the glint of the sun on the wife's legs take on the irrevocability of what has been and can no longer be doubted. Everything else can drown in the unreliable shadow of memory.[5]

Not only is the photograph a helpful tool for recalling the past, but it is the means, in this story, by which the past is *made real*. Photographs provide evidence of experiences; they substantiate the past. And they turn the lived past into a concrete "possession," as this narrator notes—small, flat, rectangular instances of time that live inside albums and make the past real.

Haviv's photos, too, are tangible artifacts. They are documents of a lived past. But when Calvino's days of "sweet anxiety" turn into years for Haviv, then moments of history (in contrast to what that short story's narrator describes) are sometimes *lost* irrevocably. Visual evidence can't always call up the past. When he

looks at his own images, Haviv's memories waver; some are strong, specific scenarios recollected and others are mere veneers, the original context of the image lost. But this doesn't lead to an illiteracy, as Benjamin might believe, or to a "drown[ing] in the unreliable shadow of memory," as Calvino has it. Haviv takes the opportunity to float, bask, and swim in this unstable realm of memory.

Many of the photographs in the pages ahead were shot as photojournalistic documents. But they were never published in a journalistic context because, after all, they were "lost." And here they appear in a far more artistic context, stripped of journalistic information. (The captions, sometimes lacking in detail due to the passage of time, are located in the back of the book.) Moreover, several of the images were chosen for this project precisely because they have—with time, wear, and destruction—aged into something that visually begs us to consider them with a fine arts sensibility, as with the cover image for this book, that looks almost as if flames of live fire lick its edges.

Haviv takes the opportunity to float, bask, and swim in this unstable realm of memory.

The curated pages of this book, a miniaturized gallery space, emphasize the liminal quality of Haviv's photos, between journalism and art, past and present, memory and loss. In creating a context that highlights the various thresholds on which these photos teeter, Haviv also calls attention to the complicated nature of reading images. We may not even be sure *how* to read these photos, because they occupy and simultaneously reject the various categories into which one tries to place them. As a result, we're forced to think about the visual grammars or implicit expectations we conventionally default to when looking at imagery.

Haviv literalizes this condition in the "broken" grammar of some of his vignettes, which read at times like fragmented thoughts, indicative of the fragmenting of memory. As Haviv says, "I began to wonder what else was I misremembering" (image 21). In turn, we could view the "destruction" of the various warped images as paralleling the gaps in memory. But such destruction has also rendered beautiful new forms. Even the "un-destroyed" images of the well-preserved negatives perform in new ways in this ahistorical, rather disjointed series. In fact, what grows from the sometimes irrevocably lost memories that are

no longer tethered to Haviv's now-found images is a new way of reading. Now, the "fiery" cover photo links with at least three others in the book: a bus engulfed in flames (image 57); Yitzhak Rabin's coffin, lying in state above a mass of flickering candles, "adorned" with enigmatic orbs of light resulting from corrosion of the negative (image 56); and a sleeping man in a restaurant, where a light leak

A photograph,
a frozen instant of time, can never tell,
or show, the whole story.

to the film has created, again, what reminds us of fire, here menacingly creeping up to the banquette (image 73). The images that were shot originally as journalistic documents are not dispossessed of that role and consequently are imbued with a richly layered, palimpsestic history. For in *The Lost Rolls*, we can also read each historical image in a newly "re-imagined" history, one where aesthetic themes allow unexpected connections, from the West Bank to Northern Ireland to Jerusalem to Mexico.

We are also, here, given special access to the unfiltered, less polished productions of a renowned photographer's eye, to see history through the themes that compelled him, whether consciously or not, whether political, personal, social, or aesthetic. Even Haviv's choice of images for this book—what made the cut— gives us privileged insight into his special way of seeing the world and thinking about the status of images as they change, conceptually and physically, over time.

A photograph, a frozen instant of time, can never tell, or show, the whole story, which is why scholars have long noted that photos encourage speculation, and also why an accurate caption is so essential to a photojournalistic image. In giving little textual information directly alongside the photos, Haviv openly reminds us of this aspect of photography. His pictures invite, even embrace, such speculation, allowing the viewer to participate in the exploration of the past: Who is the dark-haired, Madonna-like woman wrapped in a blanket (image 70)? She looks quietly at peace though also poignantly sad. And why is one t-shirt laid open when all the other clothing is balled up (image 31)? Maybe it was put there at a later point than the other items. The damage to some of Haviv's film, which in turn renders the ensuing prints hypnotic and astonishingly ethereal, can enhance the speculation. What otherworldly, almost outer space-like place is portrayed in the image on 53? The faceless subject looks like he is running away from something. One hand

obscured by a vaporous fade and a lack of contrast, it appears as though he is reaching for a gun. Those hypnotic characteristics sometimes take us out of the past and place us in the present, as we focus on the gorgeous details of damaged film, the new imagery that "overlays" the old. How uncanny, for instance, that the subject of image 7 is now framed, by a ghostly halo encircling his face, within the frame of the photo itself.

In the end, *The Lost Rolls* highlights an inherent facet of photography in beautiful manifestation: Photos can never resurrect the past, as much as they are sometimes considered agents of memory. But they *can* powerfully compel a viewer to look, and more so, to read the image, both its past and its present. Such is the "afterlife" of photographs like Haviv's. And so we swim adrift in these images, in a river of history out of order and context, but oh so beautifully beguiling.

[1] Benjamin, Walter. p215. "A Short History of Photography." In *Classic Essays on Photography*. Ed. Alan Trachtenberg, pp199-216. New Haven, CT: Leete's Island Books, 1980.

[2] Holmes, Oliver Wendell. "The Stereoscope and the Stereograph." *The Atlantic Monthly* (June 1859). Available at: < http://www.theatlantic.com/magazine/archive/1859/06/the-stereoscope-and-the-stereograph/303361/>

[3] The title of this multi-volume novel, originally published in French between 1913 and 1927, has also been translated as *In Search of Lost Time*.

[4] Proust, Marcel. p246. *Remembrance of Things Past: Time Regained*. Trans. Stephen Hudson. London: Chatto and Windus, 1931.

[5] Calvino, Italo. p220. "The Adventure of a Photographer." In *Difficult Loves*. Trans. William Weaver, Archibald Colquhoun, and Peggy Wright, pp220-235. New York: Harcourt Brace & Co., 1984.

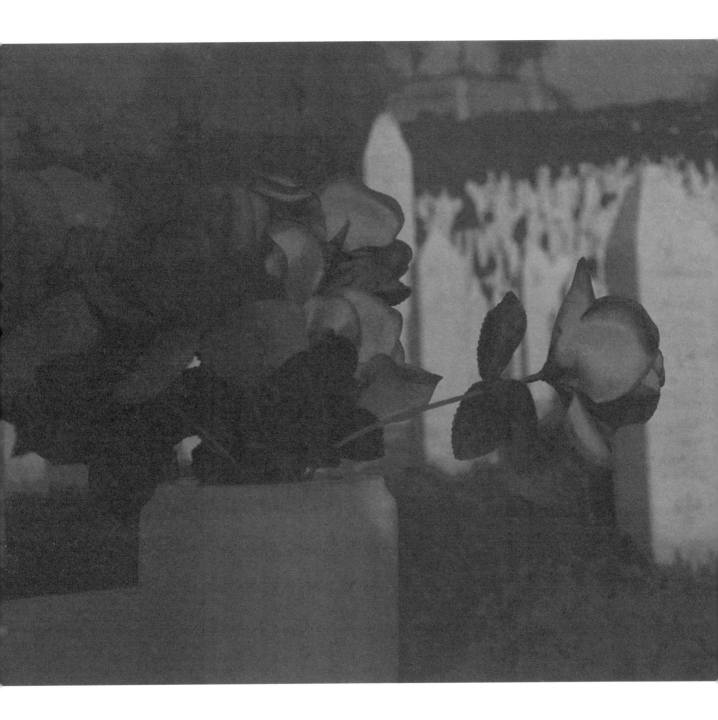

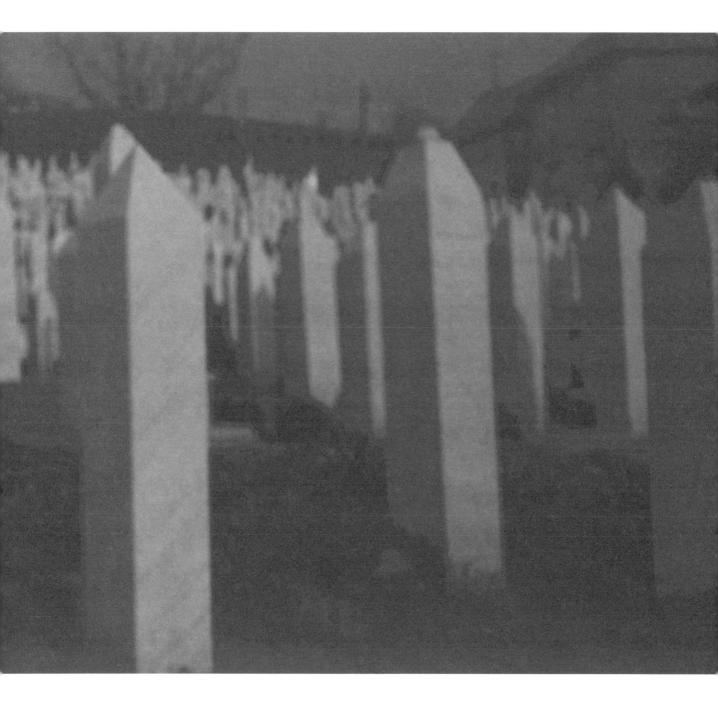

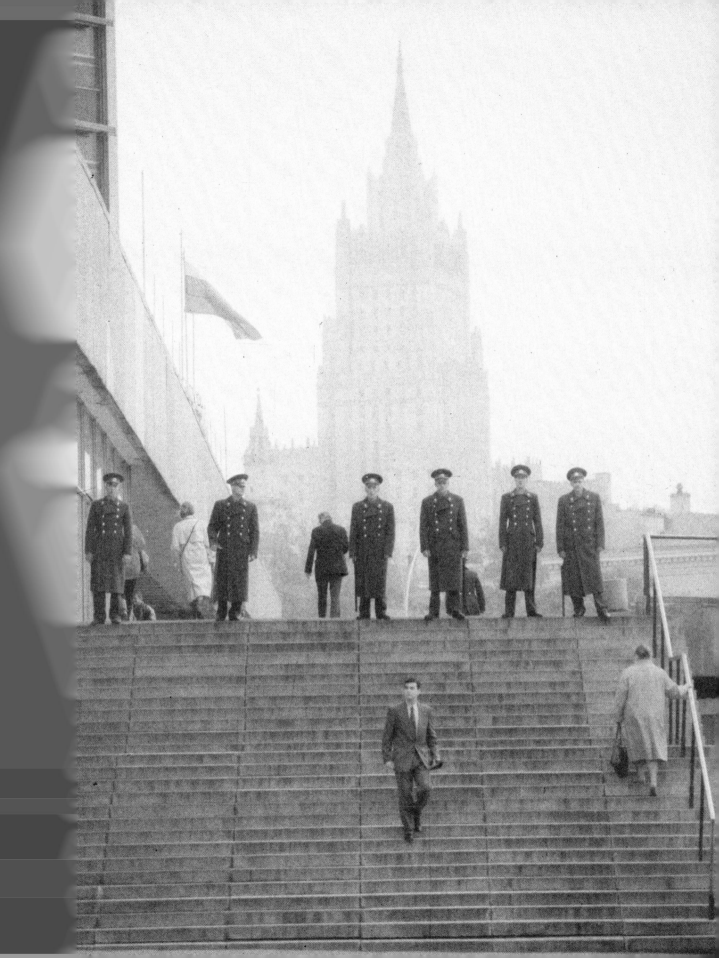

the government was dissolved in moscow and so i was headed to a new part of the world,

uncertain of what was to come. days passed, confusion reigned.

one morning, troops appeared on the streets. no one knew their allegiance.

members of parliament, living in the past, held fast to dreams of communism.

violence disrupted daily life. civilians, protestors, and journalists dying in the streets. once the rebellion was over,

the last remnants of communism crumbled, and its symbols no longer flew over the city.

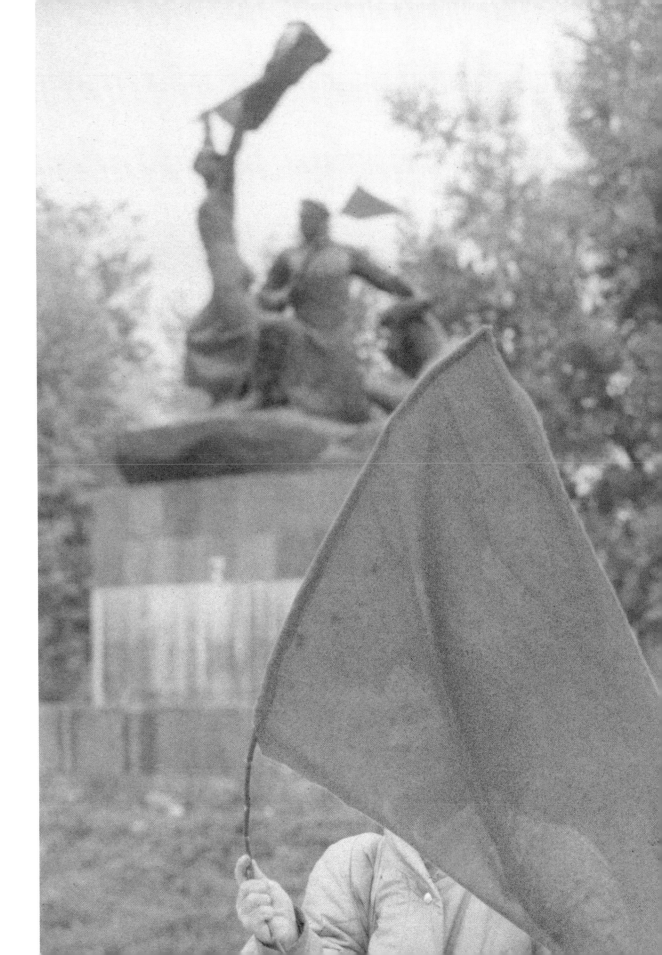

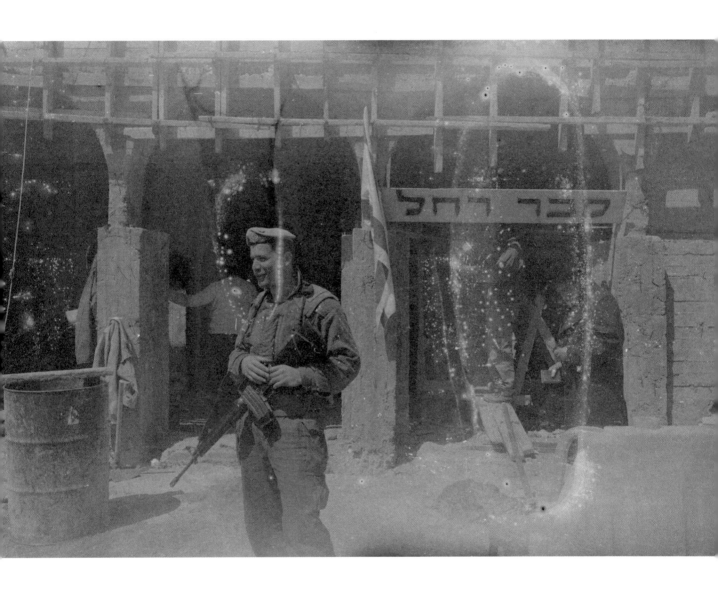

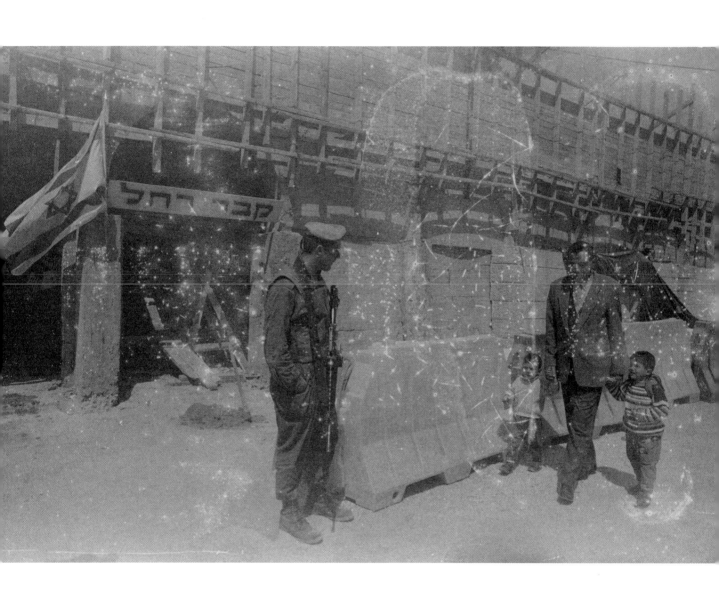

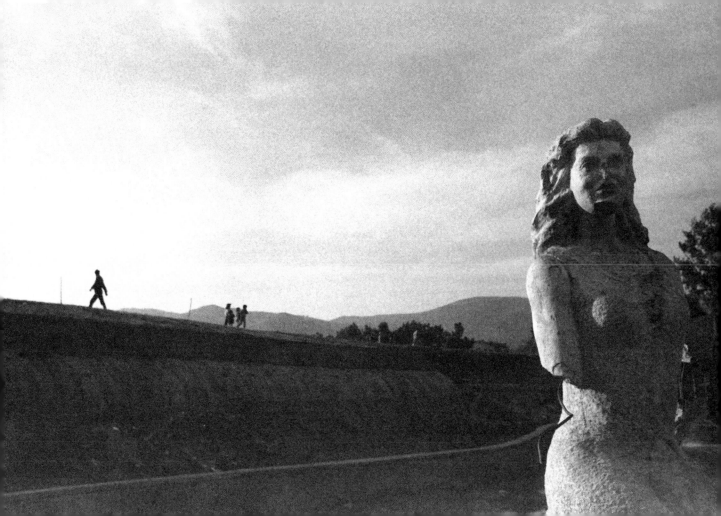

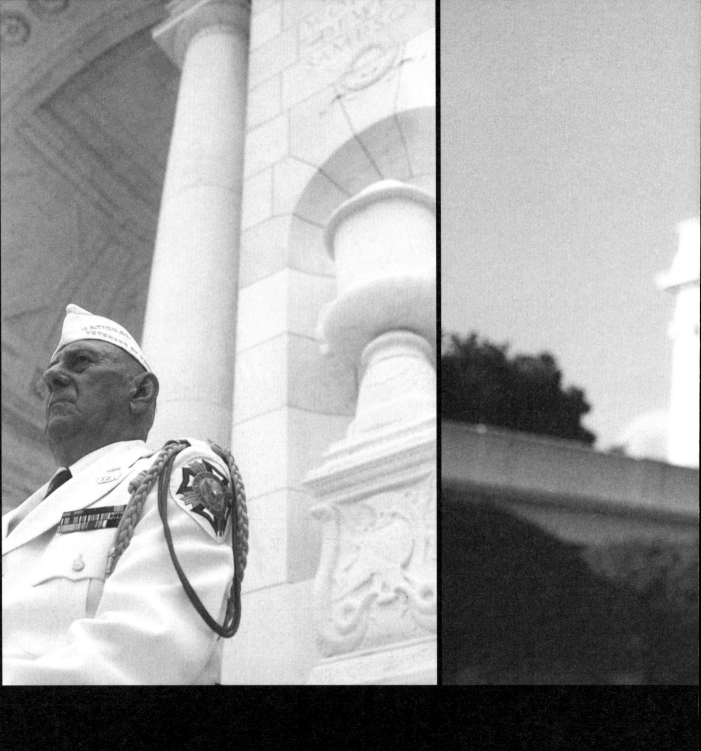

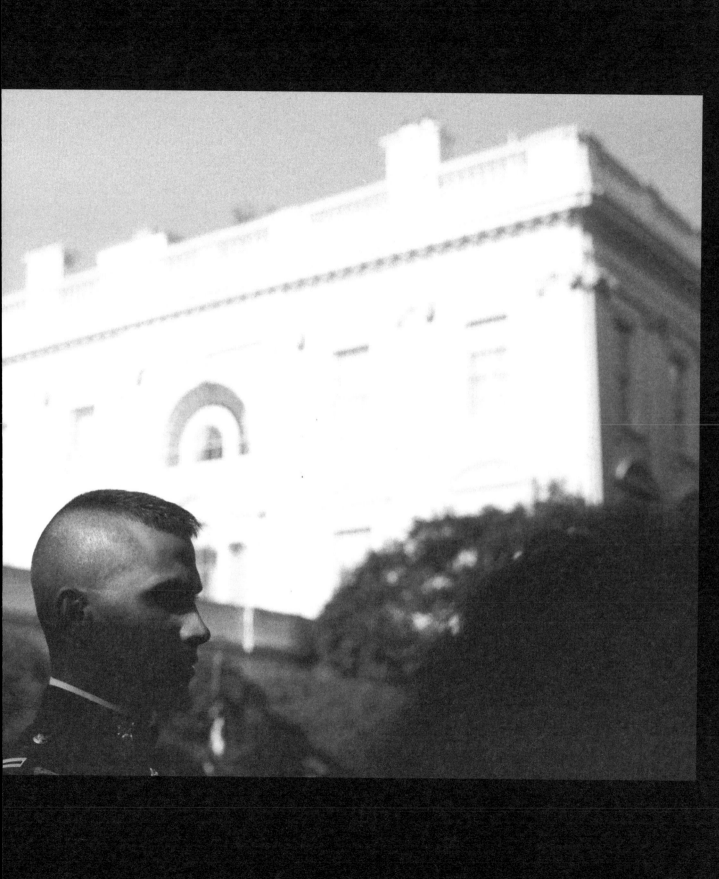

my first return to bosnia since the end of the war.

visiting places that i photographed in conflict, bridges replaced damaged

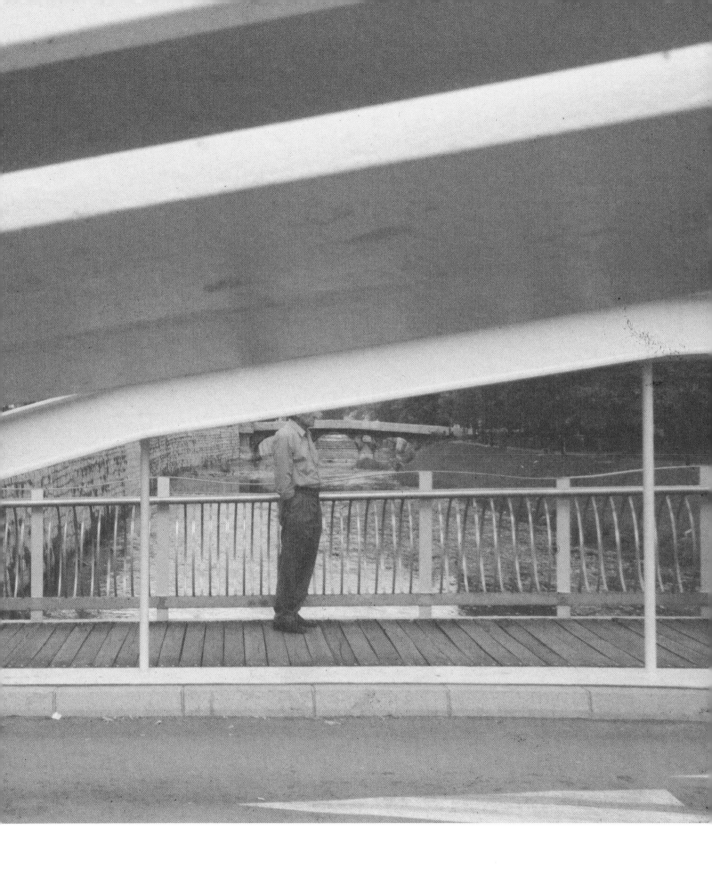

footwalks, shell markings mended but visible,
left me feeling that i wasn't sure whether peace had arrived or that people wanted it.

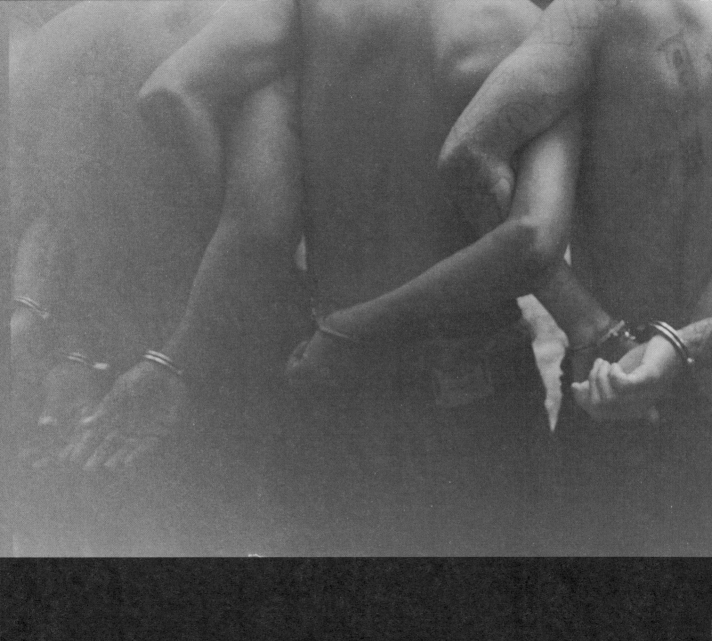

gang violence in el salvador-victims turning up on street corners,
wakes being held in market places, i saw police

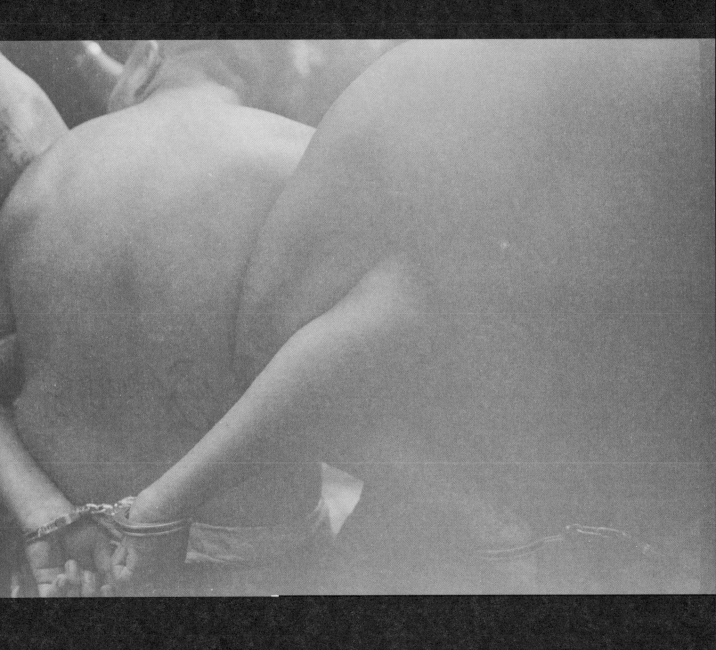

moving one way while gangs moved the other.
the salvadoran world was coming apart from all sides.

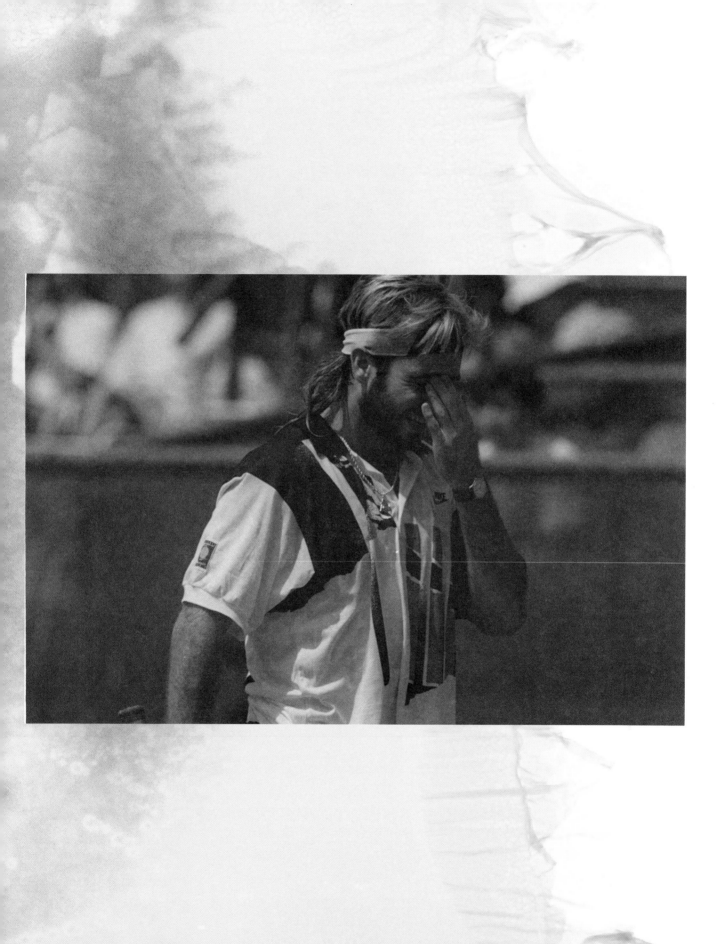

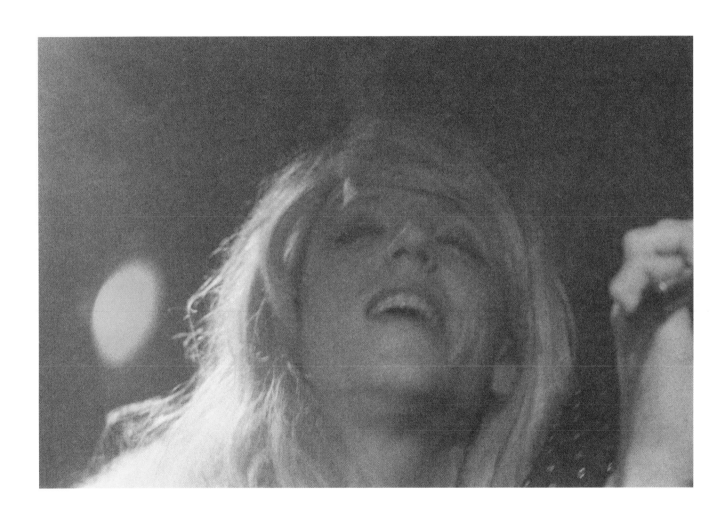

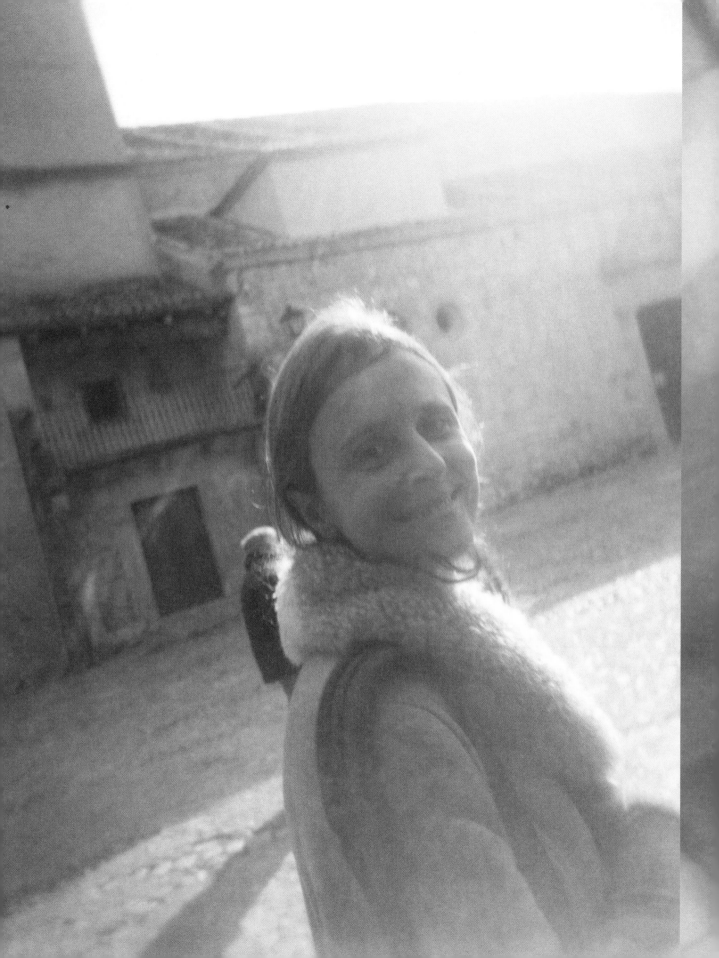

she was there in the early days, learning what it meant to be a photographer,
how to work in a world of violence and uncertainty.
experiences intertwined with friendships, eventually creating something more than our photographer selves.
losing her after so long yet so short a time is a reminder that what we create,

day in and day out, remains visible long after we are gone.

the word "incident" written on the wall, a haunting marker of where one of the first war crimes of the bosnian war occurred.

my photographs were pieces of the events of the day.

yet my memories didn't connect with the reality of the place, i realized when i returned for the first time.

most distressing—the street i had remembered as being vast,

and where I was protected from being noticed...it's actually quite narrow,

and I was, in reality, a lot closer to the executions than i'd remembered.

i began to wonder what

else was i misremembering in my memory.

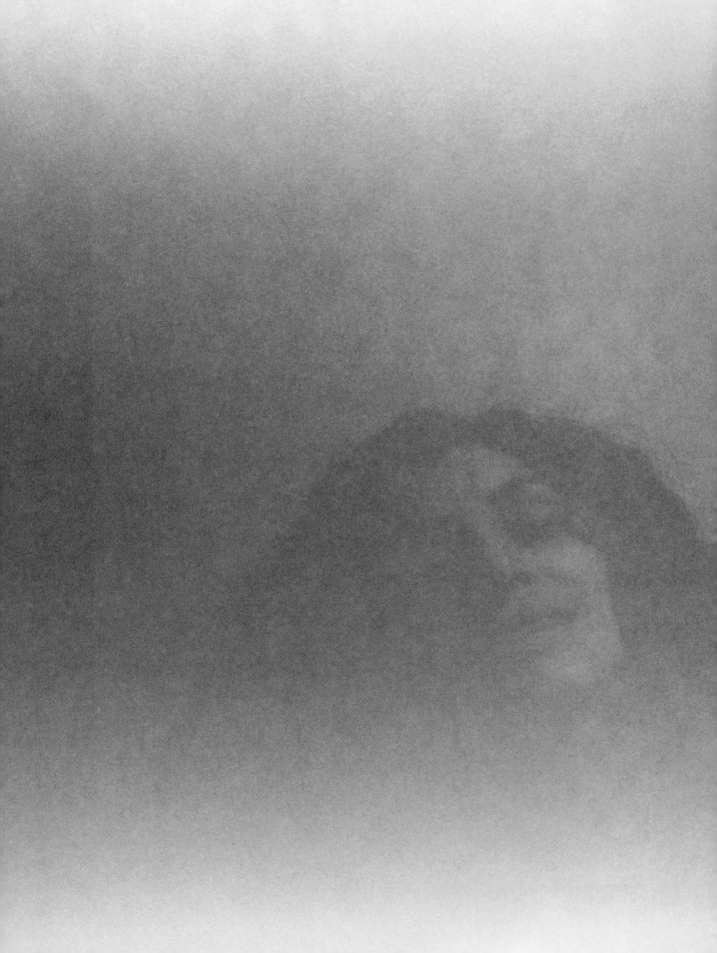

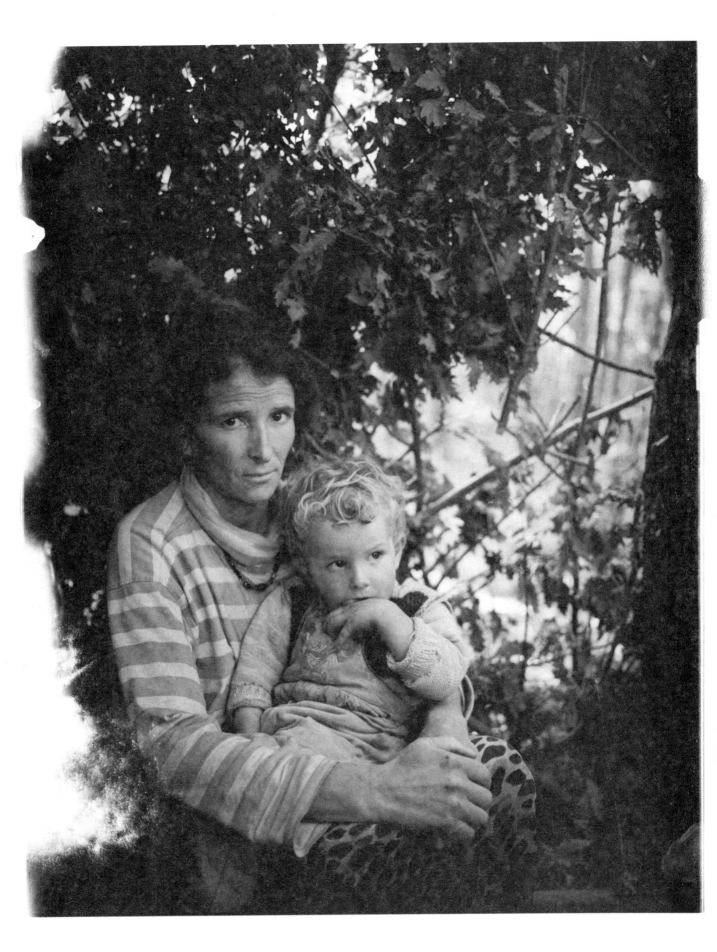

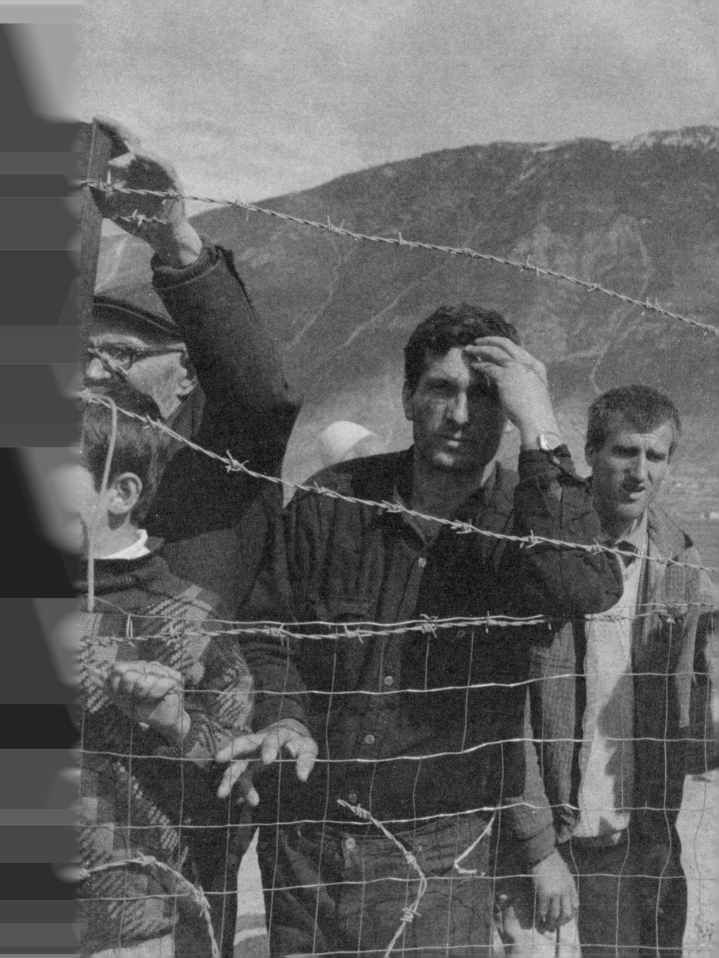

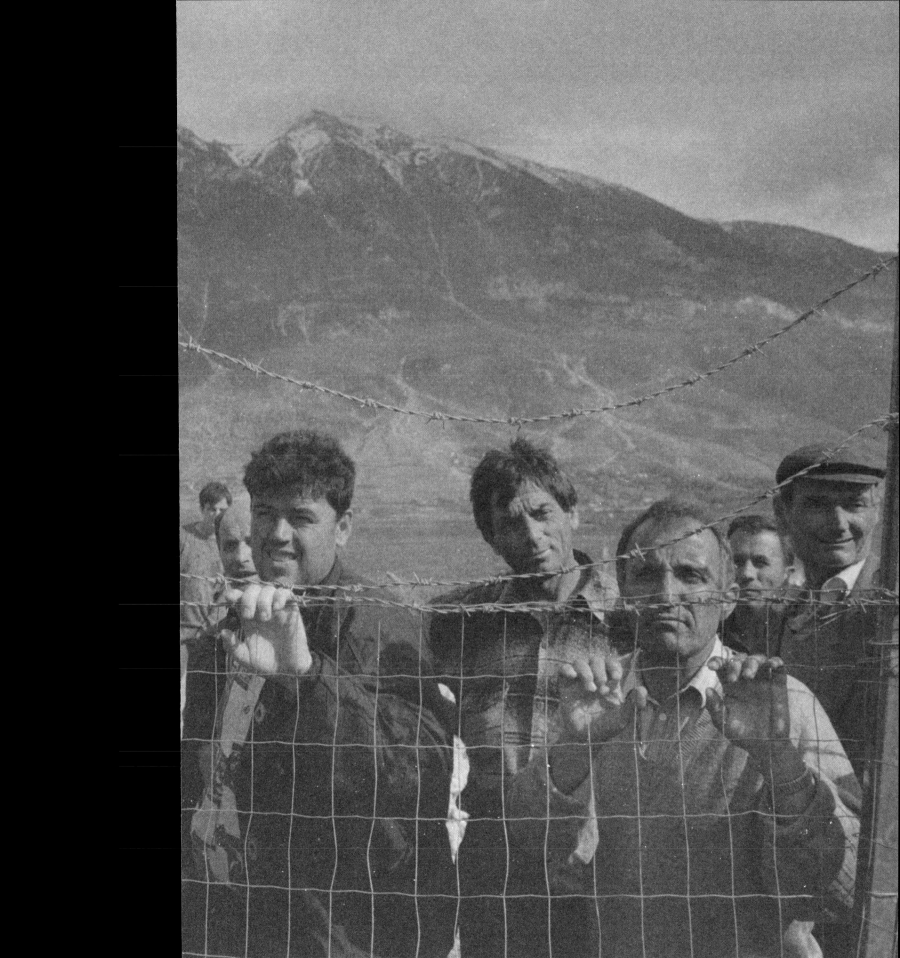

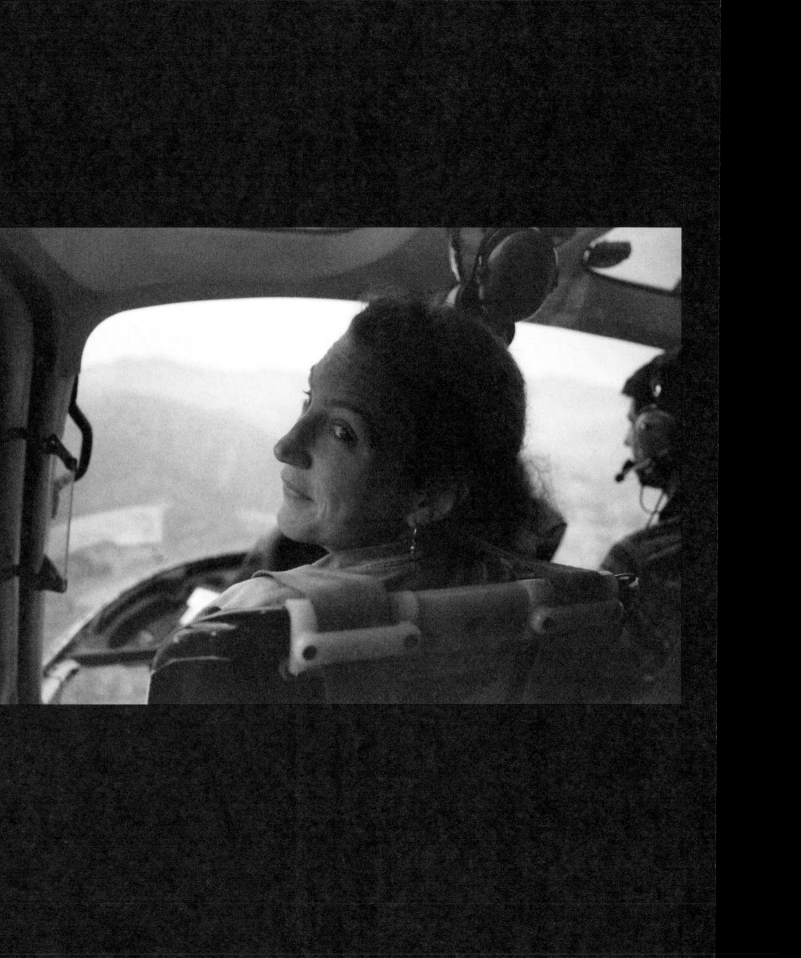

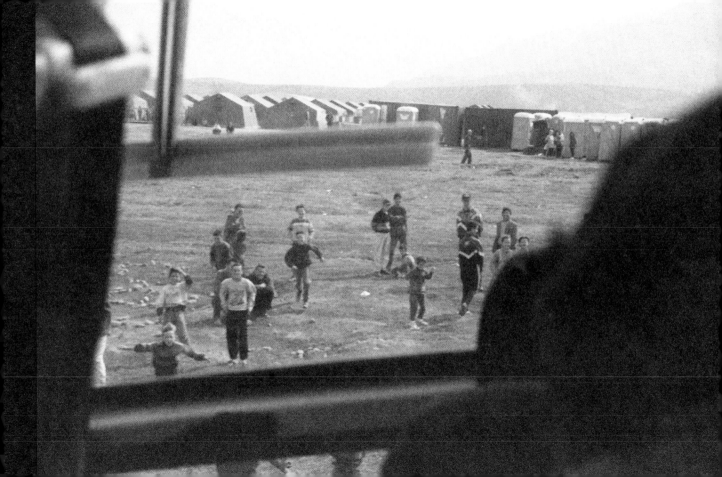

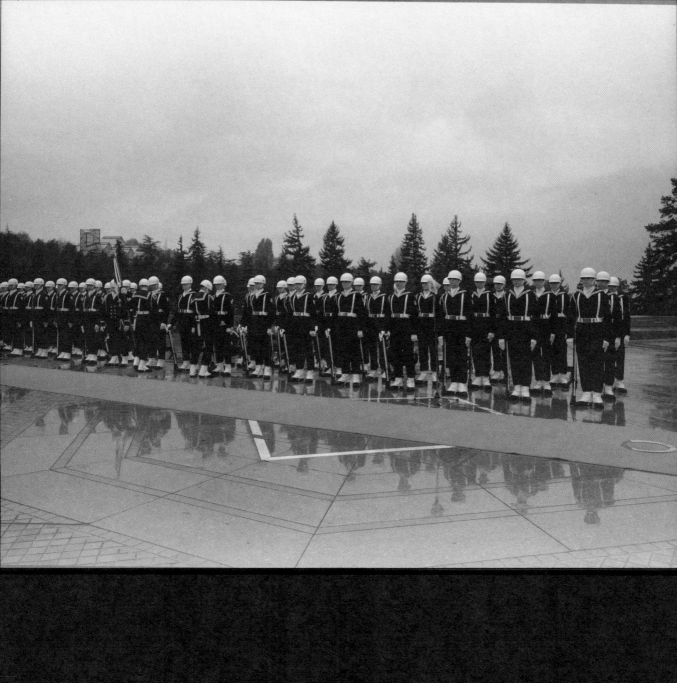

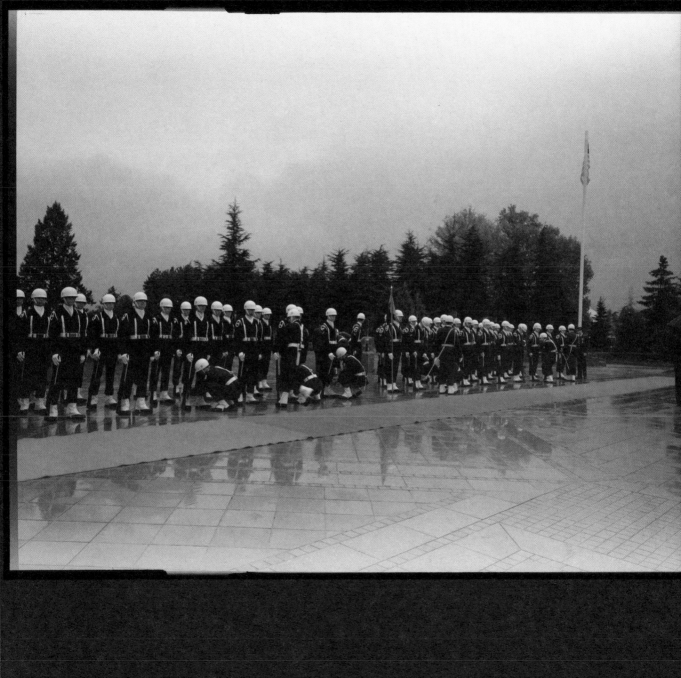

the mountains and woods surrounding srebrenica offered a grave to most and escape to a few.

one year later, trying to understand all that had occurred...

the last moments as men and boys fled the guns in vain, as victims tried to breathe while the poison surrounded them..

these searches led to brutal pieces of evidence of the war crime

as i wandered around, so did others, some similarly trying to find proof, others trying to make sure nothing surfaced

that told the story of what had happened during that fateful time.

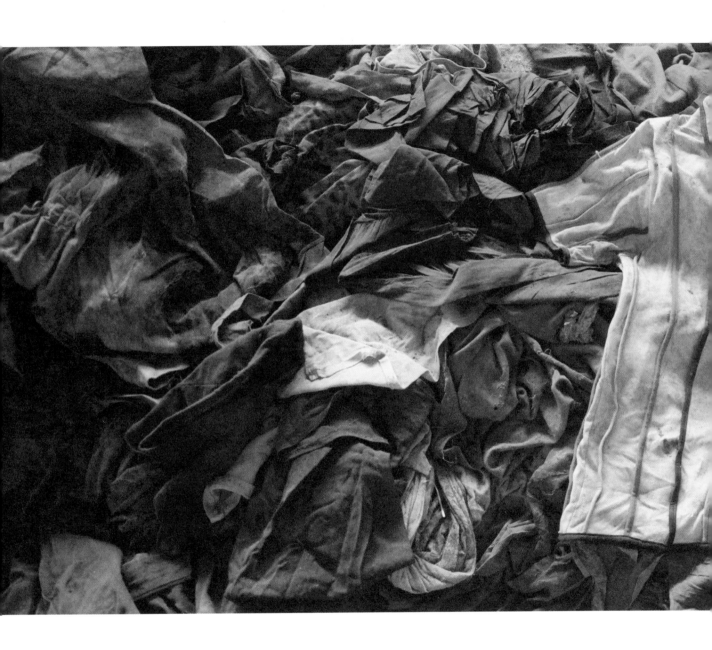

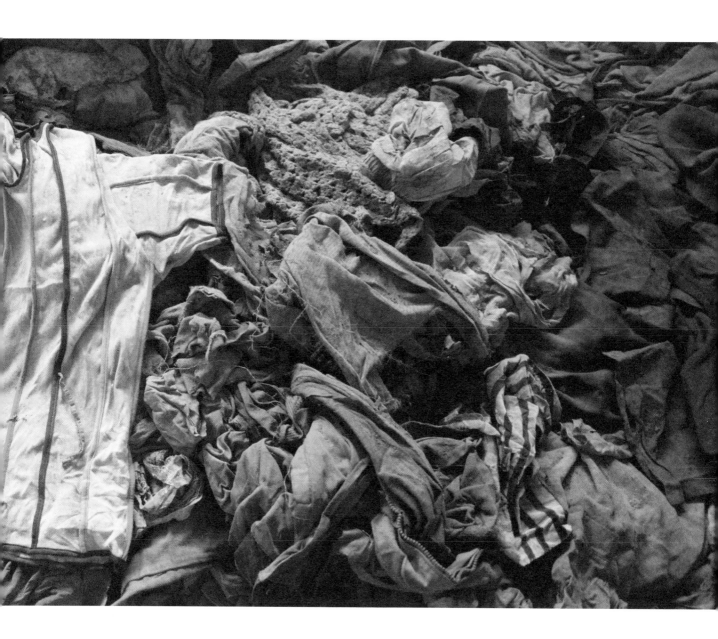

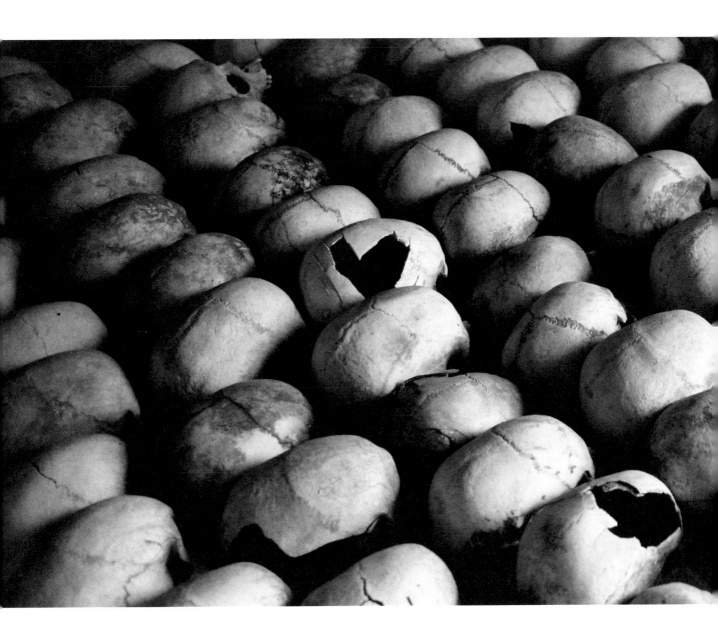

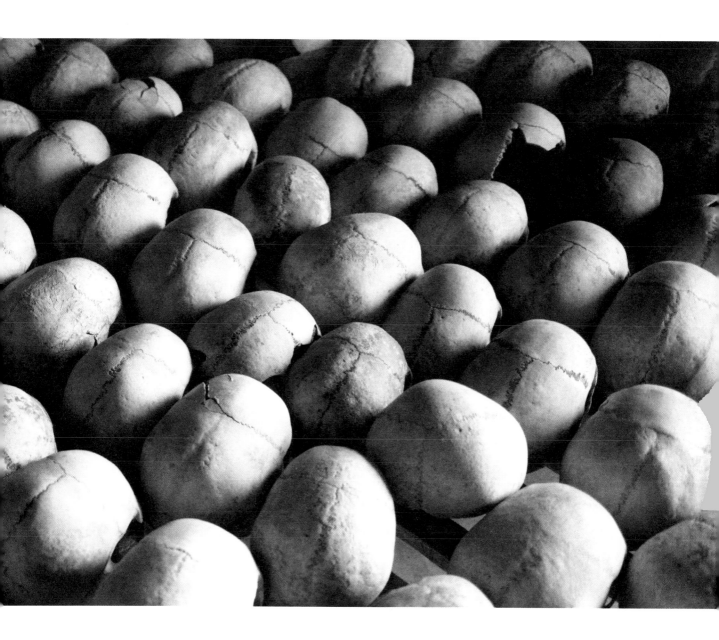

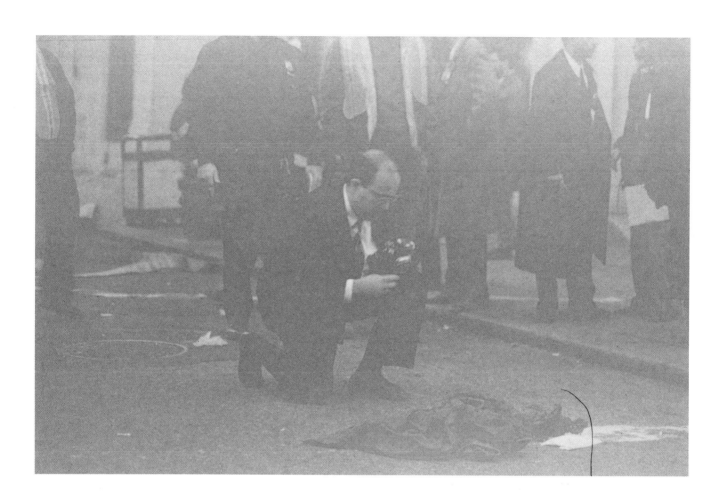

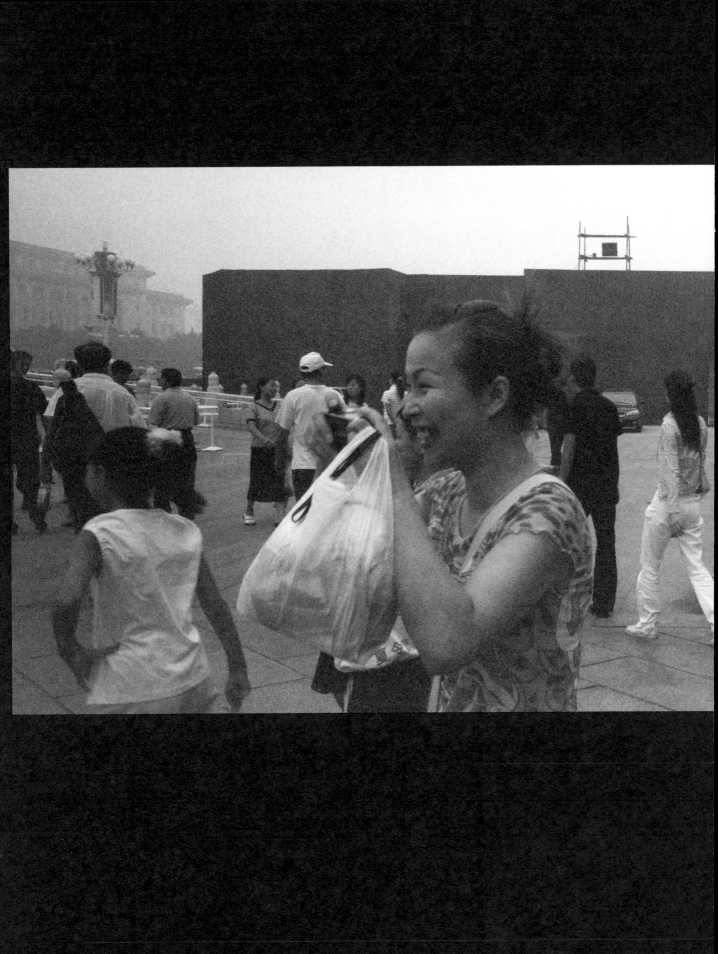

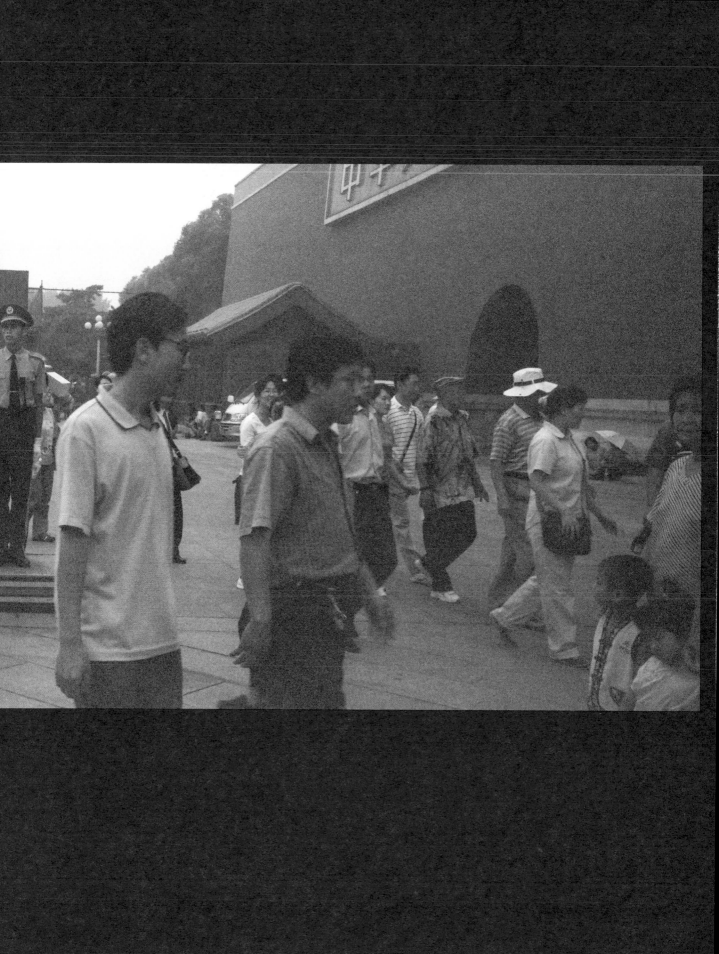

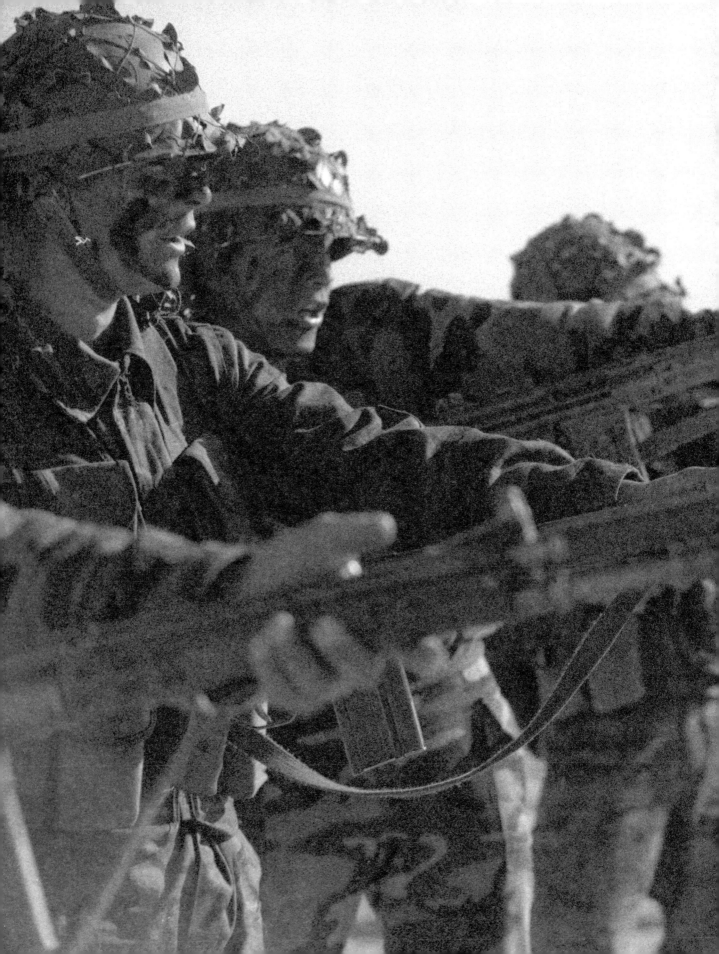

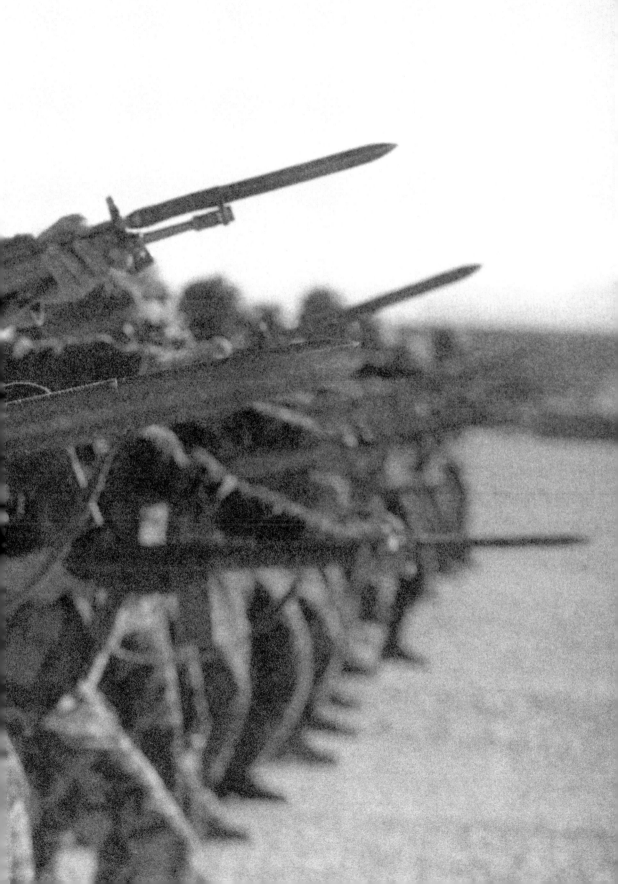

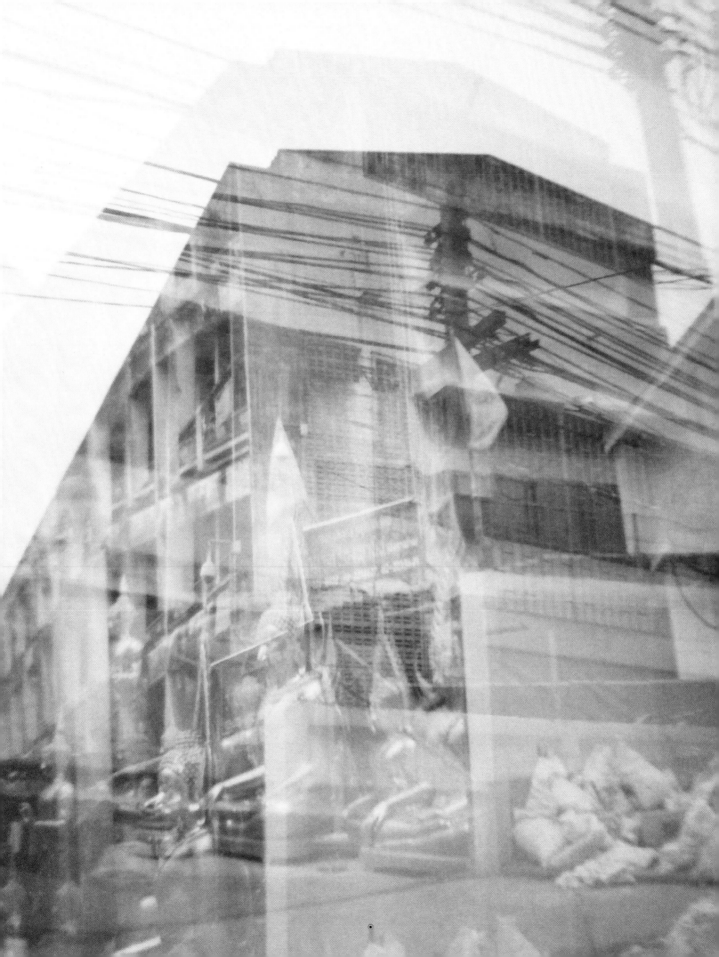

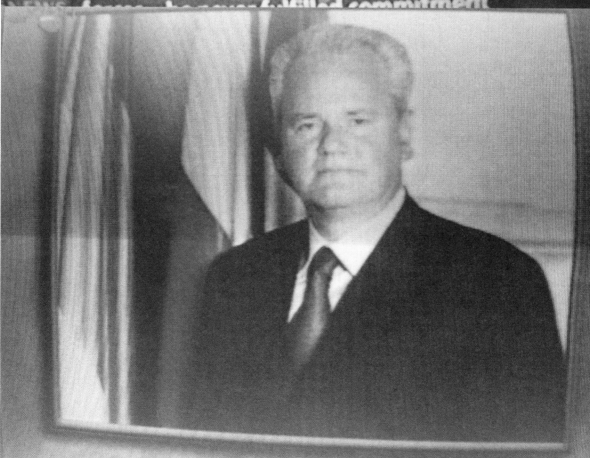

3:37 KOSOVO CRISIS

SKY Blair: Milosevic undertook to withdraw
NEWS _____ _____ _____ fulfilled commitment

AM

STRIKE
AGAINST
YUGOSLAVIA

RUSSIAN PRESIDENT
YELTSIN URGES RESTRAINT

CNN

PM

STRIKE
AGAINST
YUGOSLAVIA

US FIGHTER JETS
DEPART ITALY

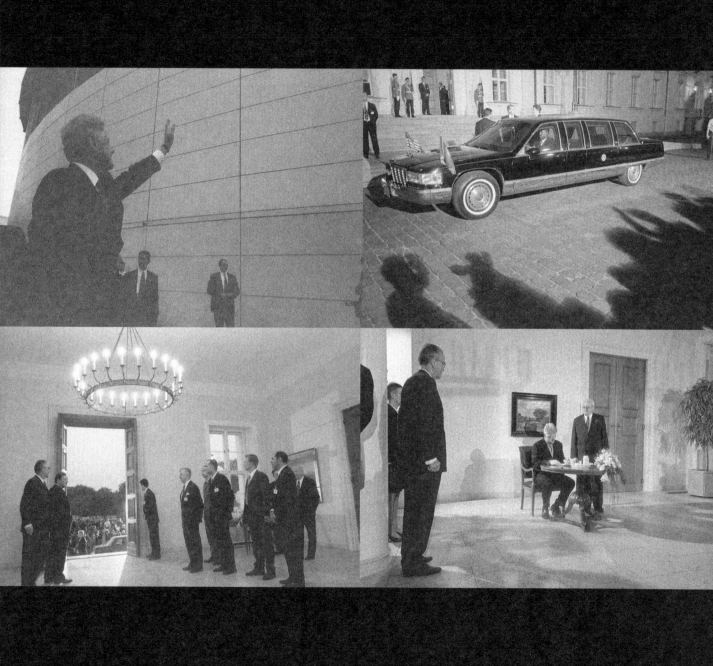

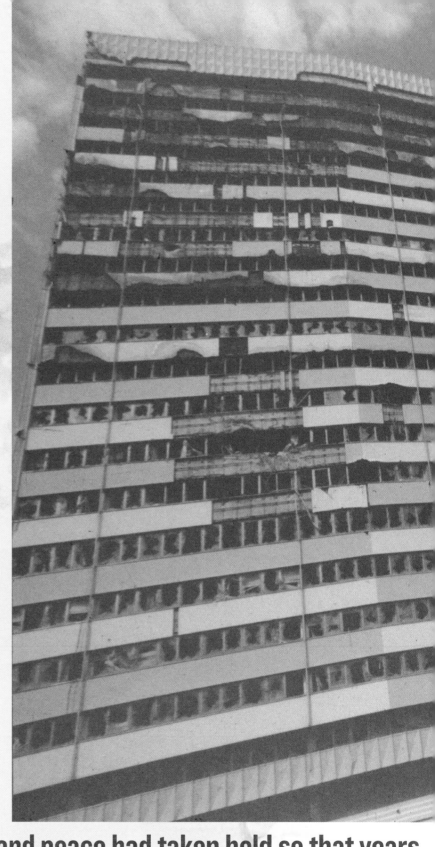

fighting had stopped and peace had taken hold so that years

looking at the golden holiday inn hotel that had protected me in the beginning months of the war

feelings ranging from happy for some type of protection to wondering when shells and bullets were piercing from one side of

a few anxiously long but, in actuality, brief moments.

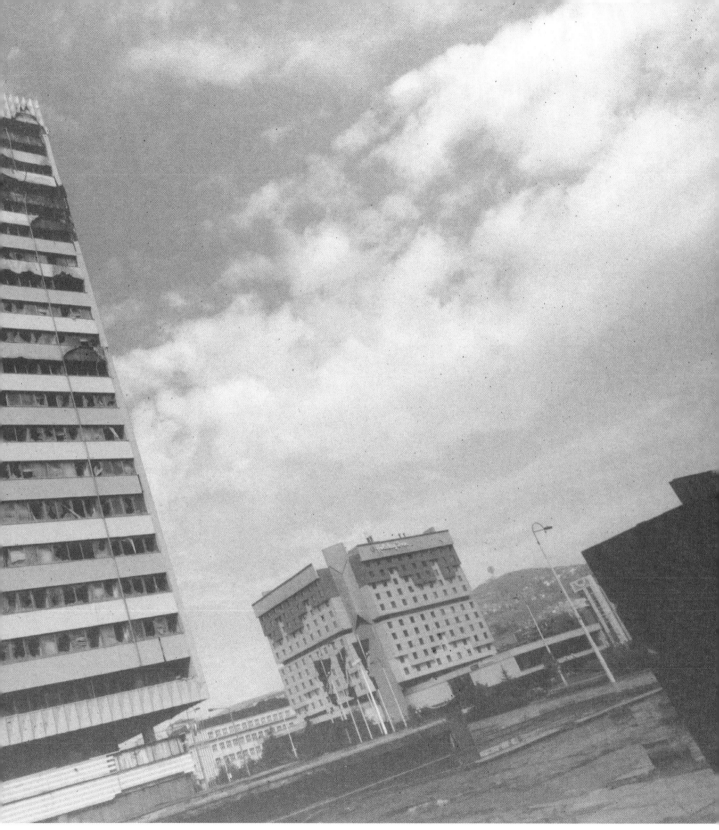

later i could walk on the street once known as "sniper alley."

reminded me that the building was target practice for the opposing serbian side. days and nights in the hotel...

the building to the other. leaving the hotel, exposed to sniper fire...

going in and out was an adventure.

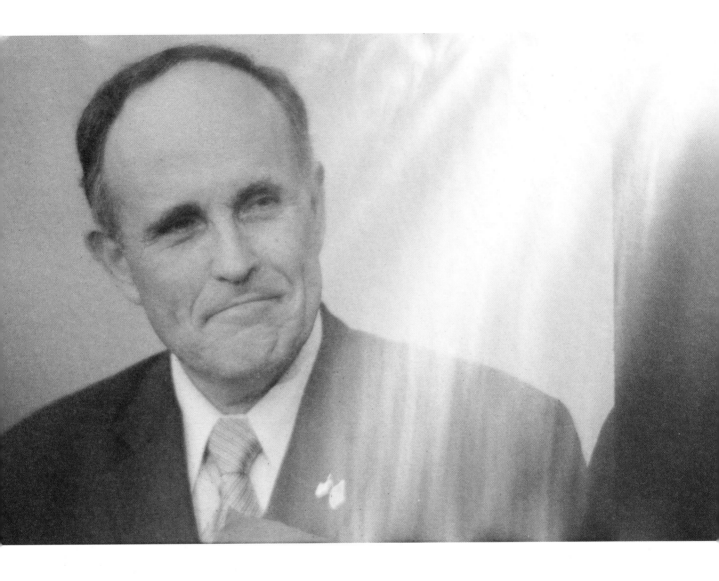

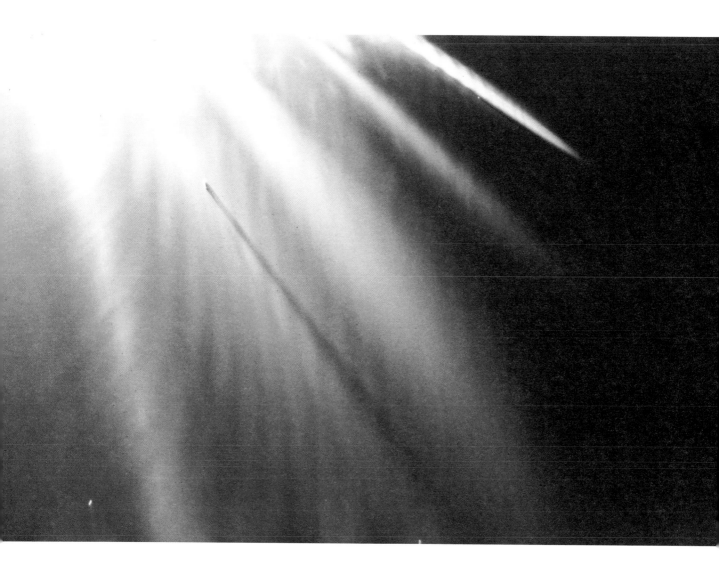

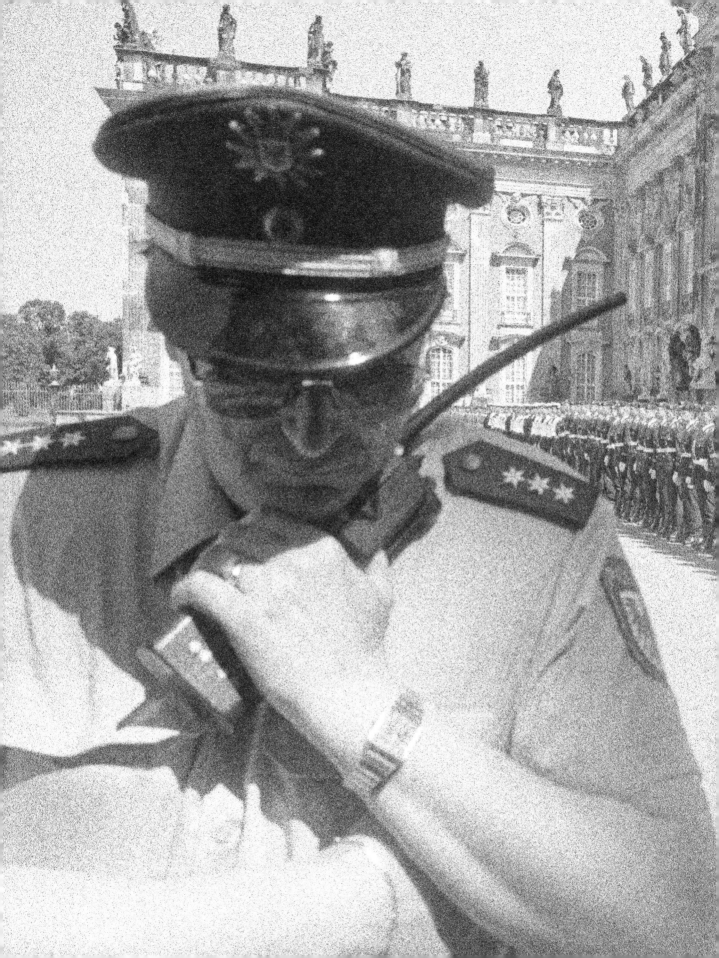

traveling air force one had perks...moving around with

empty famous vacation spots...bill and hillary, chelsea in tow, seeing

the president meant no traffic,
the best that turkey could offer
as they left, the true owners of this place took their rightful spot.

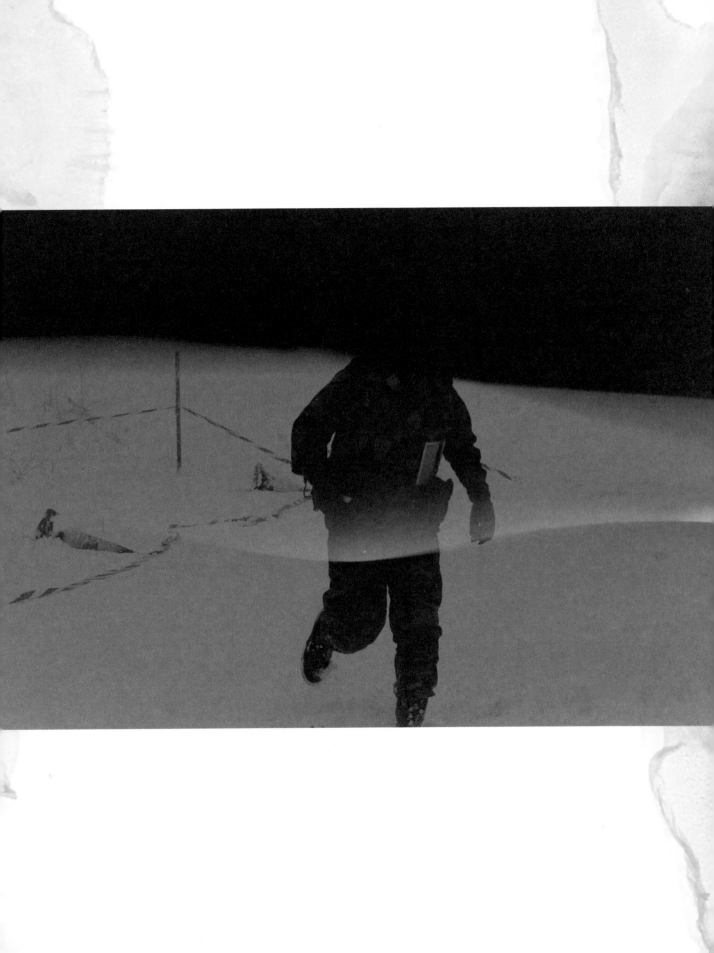

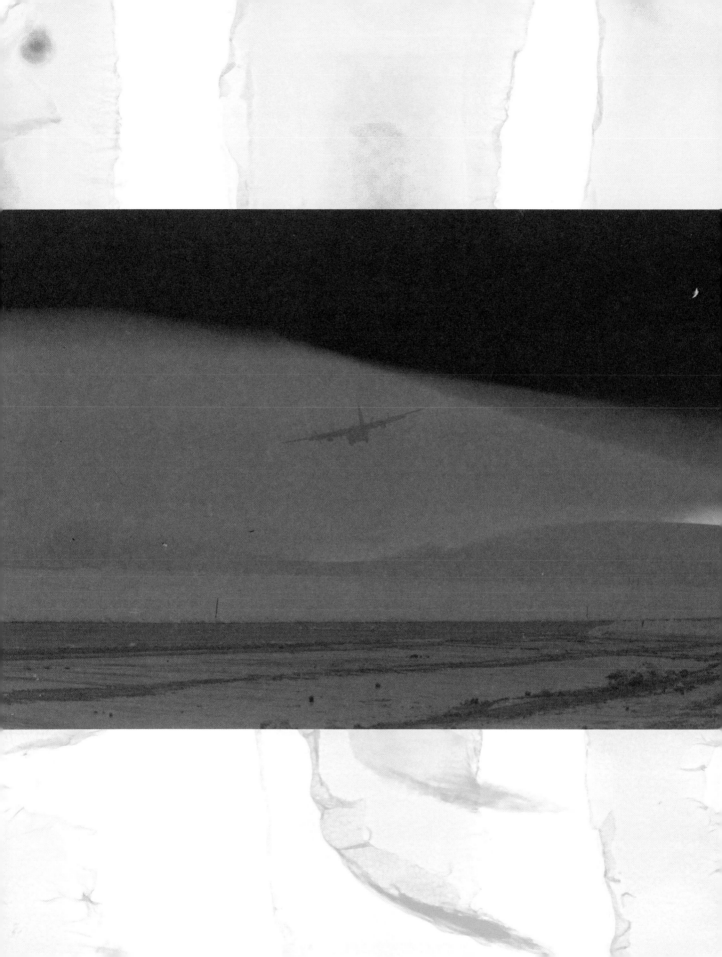

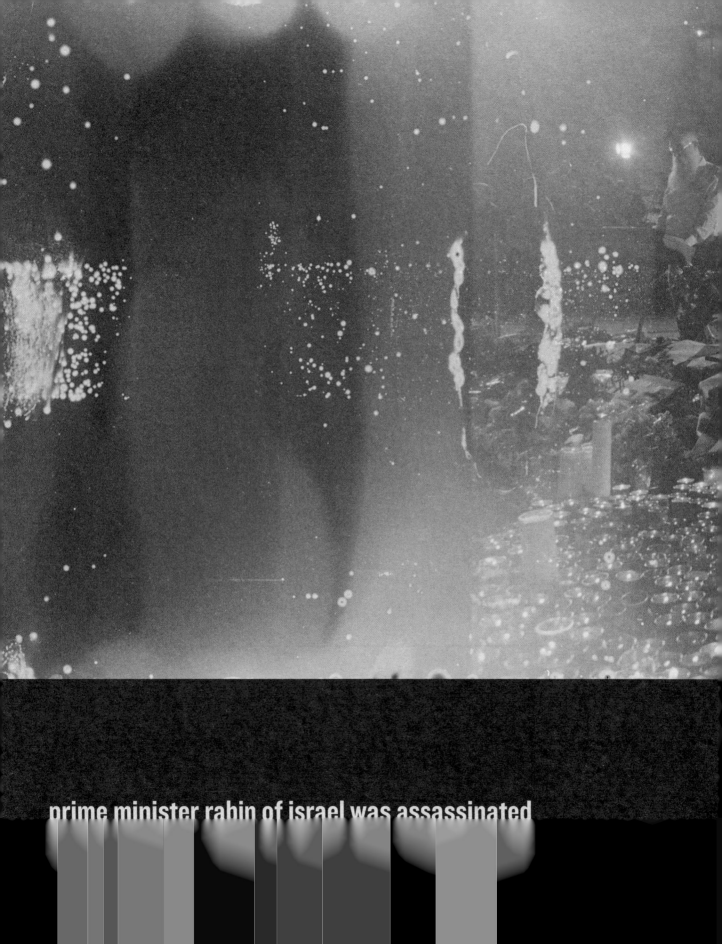

prime minister rabin of israel was assassinated

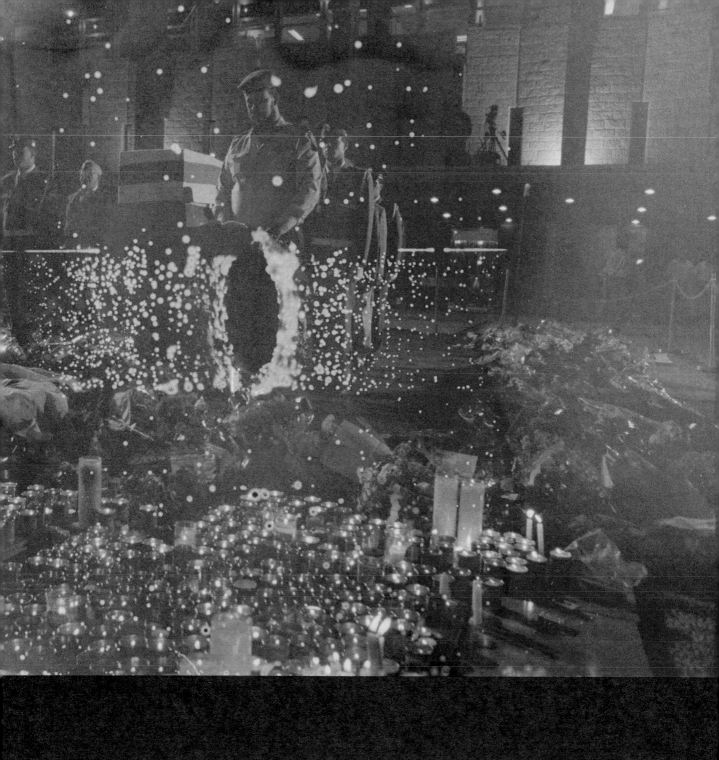

the subsequent days of mourning and confusion

days of photographing the years of violence and despair.

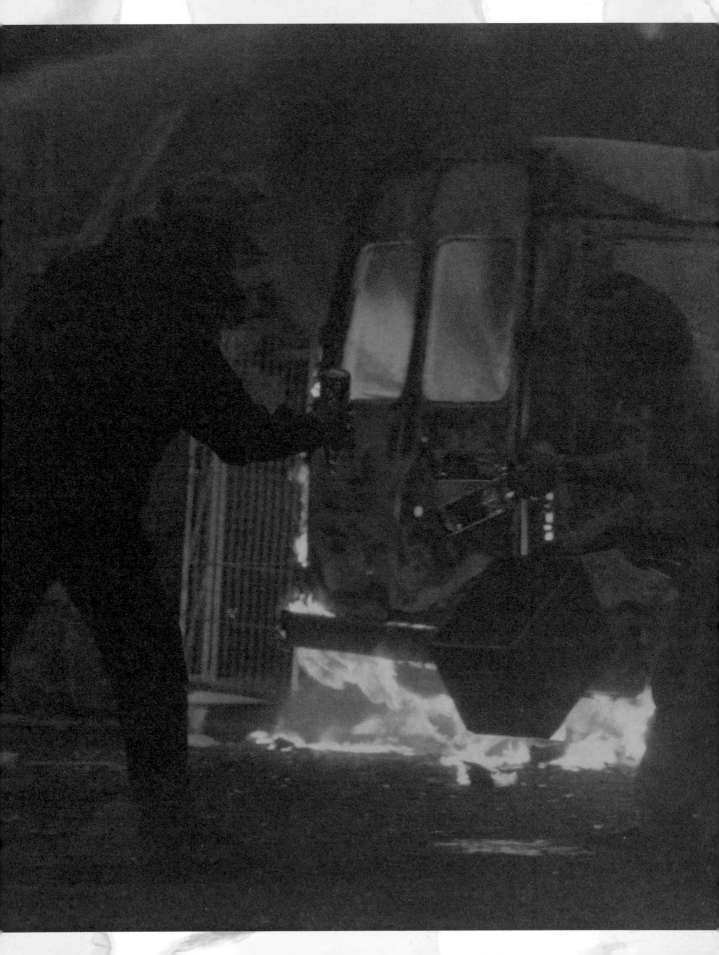

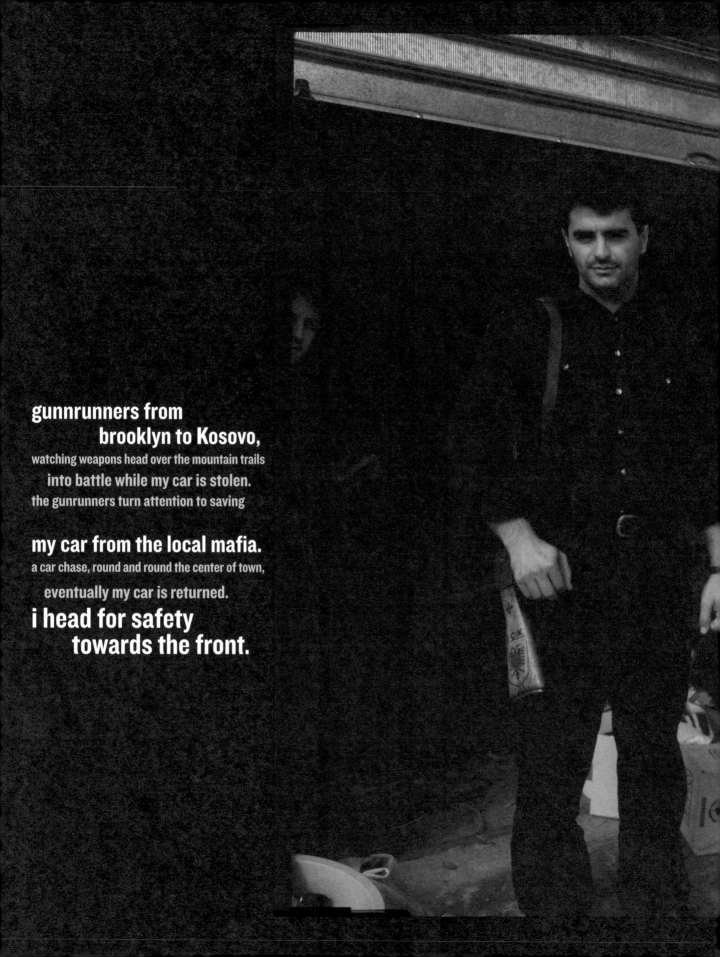

gunnrunners from
 brooklyn to Kosovo,
watching weapons head over the mountain trails
 into battle while my car is stolen.
the gunrunners turn attention to saving

my car from the local mafia.
a car chase, round and round the center of town,

 eventually my car is returned.
i head for safety
 towards the front.

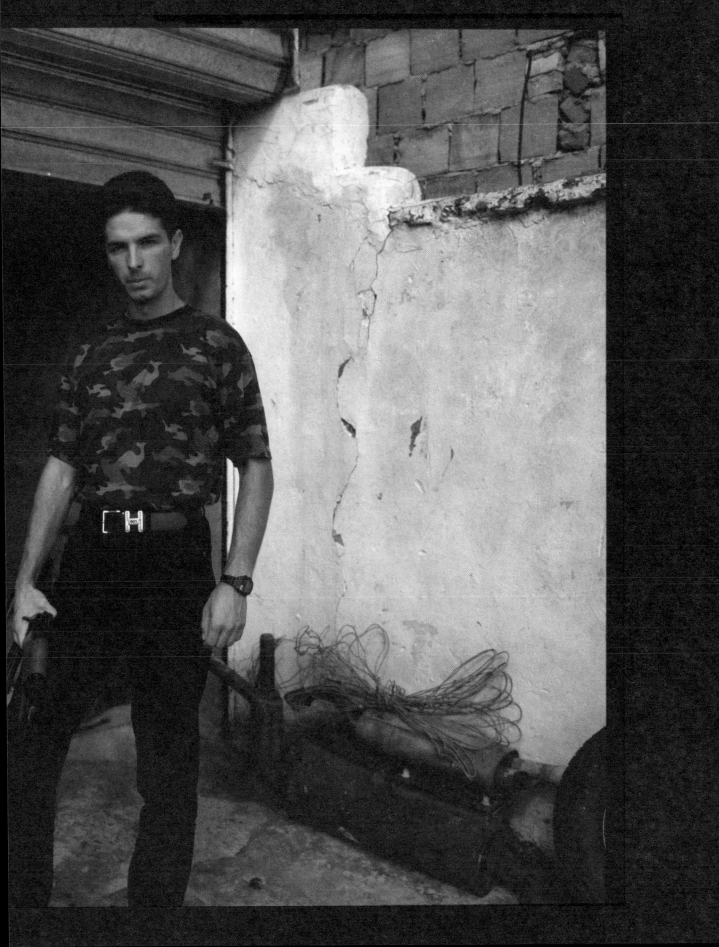

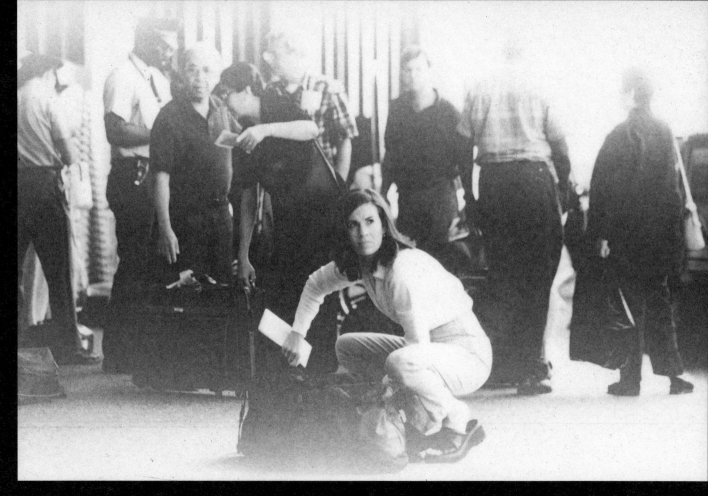

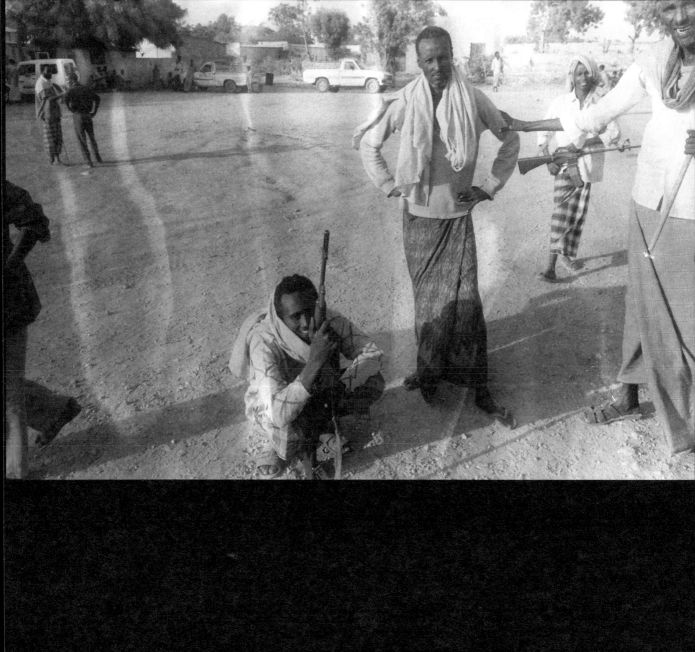

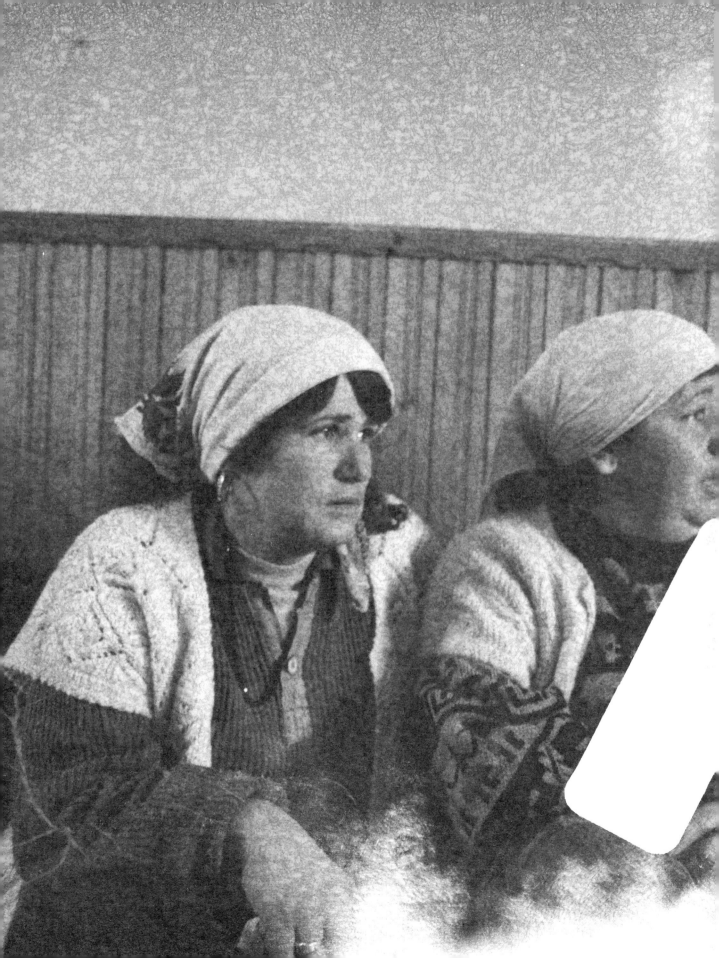

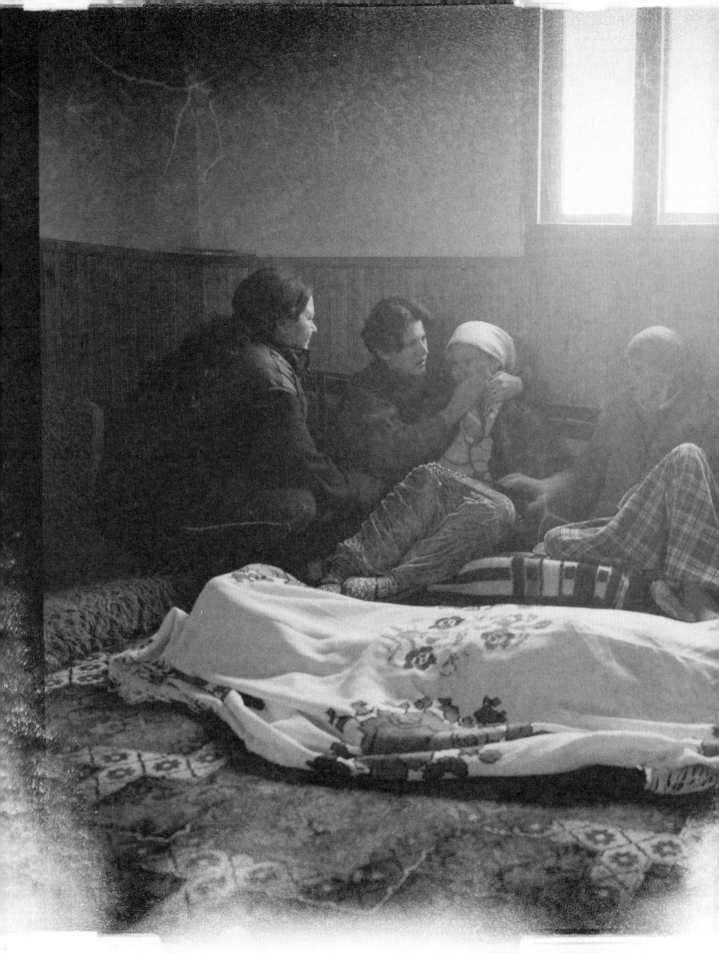

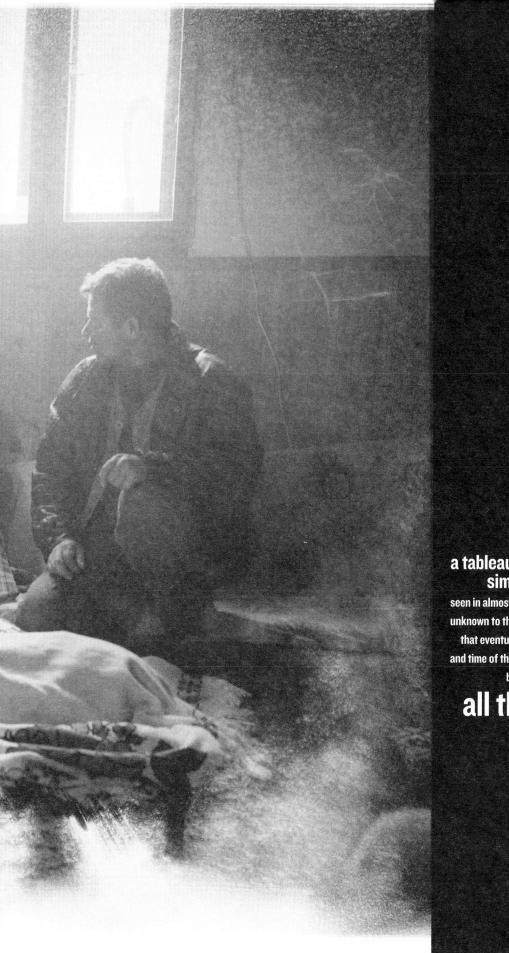

a tableau, universal in its
simplicity of ritual mourning,
seen in almost every place i've been— another loss,
unknown to the world, adding up to staggering numbers
that eventually overwhelm the mind. the general place
and time of these scenes of mourning remain accessible,
but the rest of the details fade away.

all that is left are
fragments.

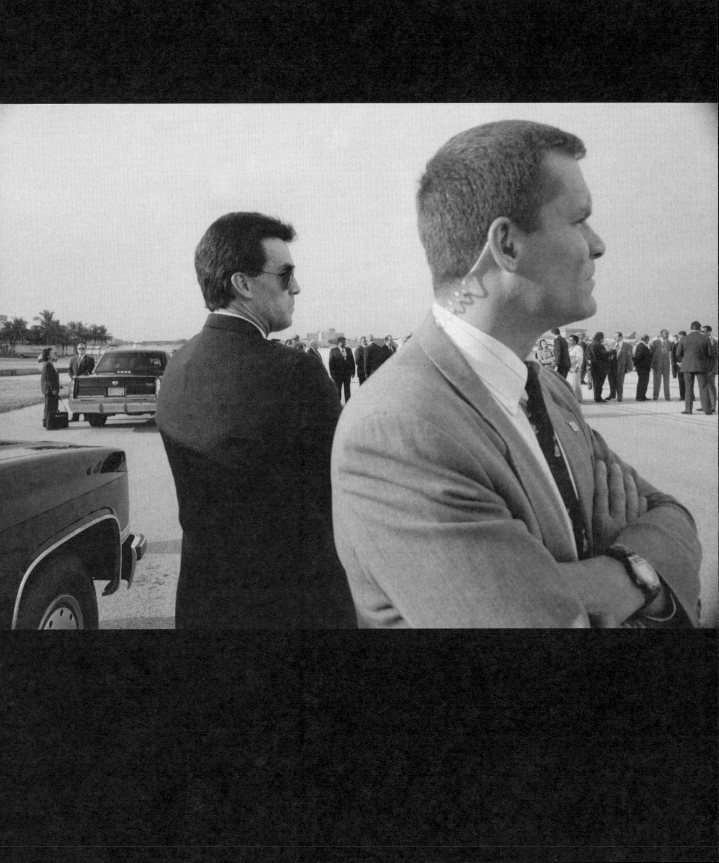

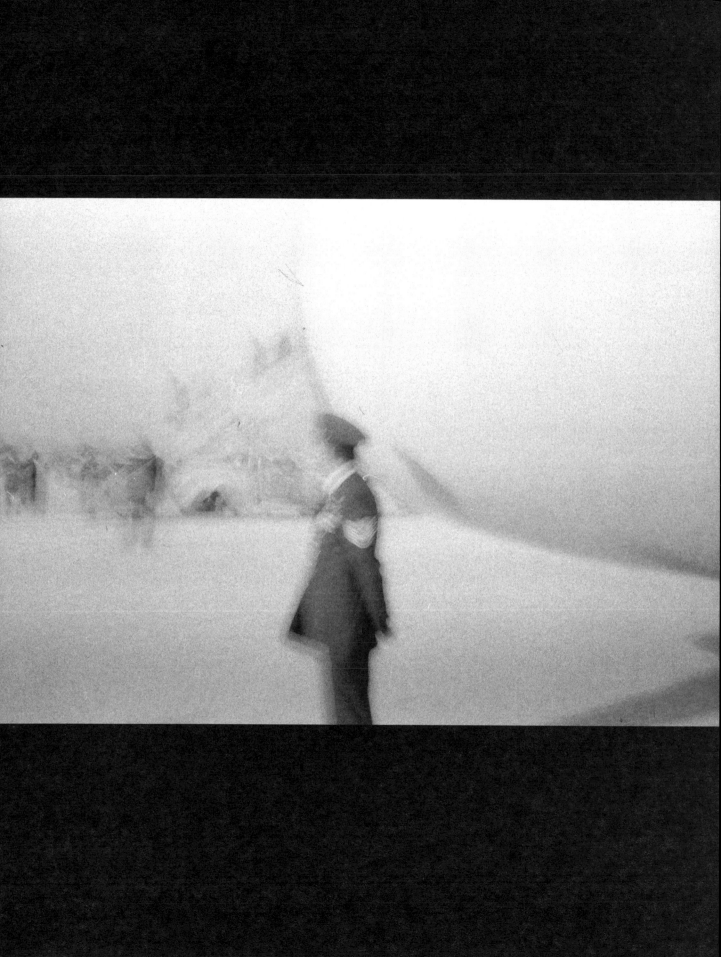

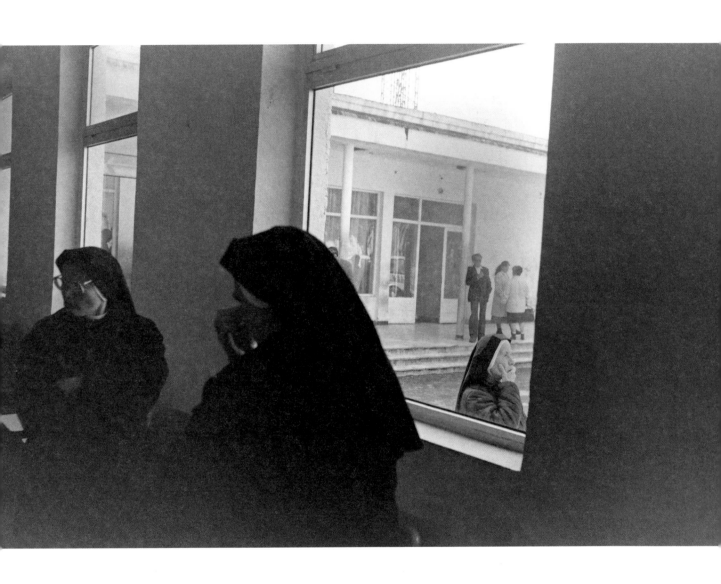

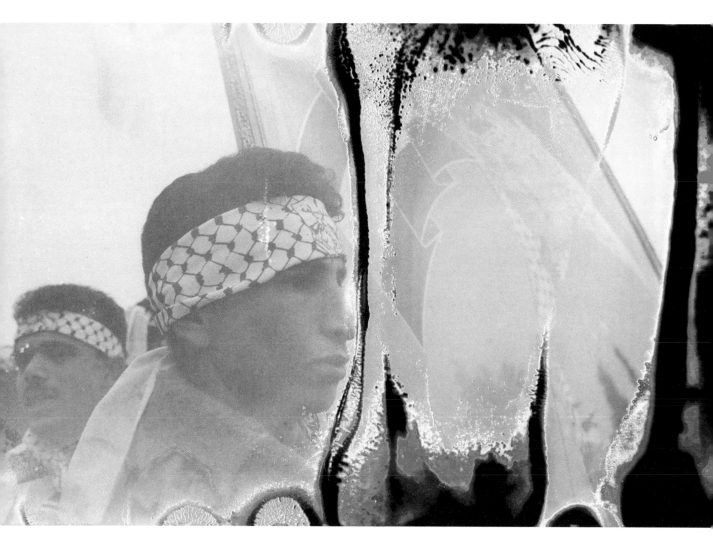

another demonstration, another day of frustration in the west bank.

ebbs and flows of possibilities continued throughout my time working on the ground there.

i'm remembering when

there were options for hope and when there were no possibilities...

it all blends into the idea that nothing can really move forward.

life fraying at the seams, sometimes ripping to pieces, is the norm in this place.

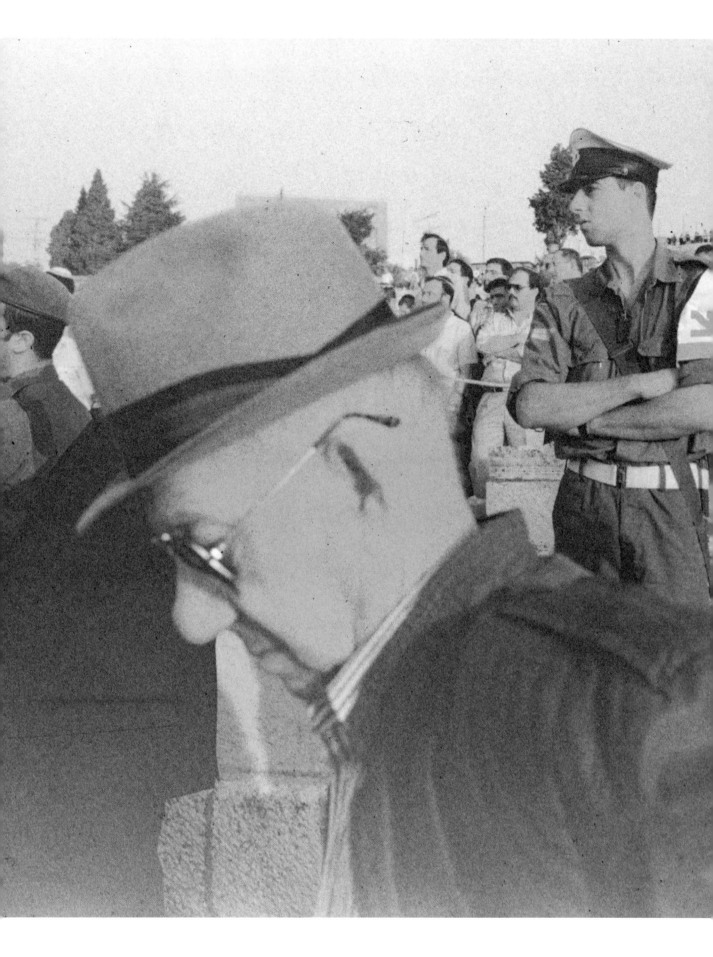

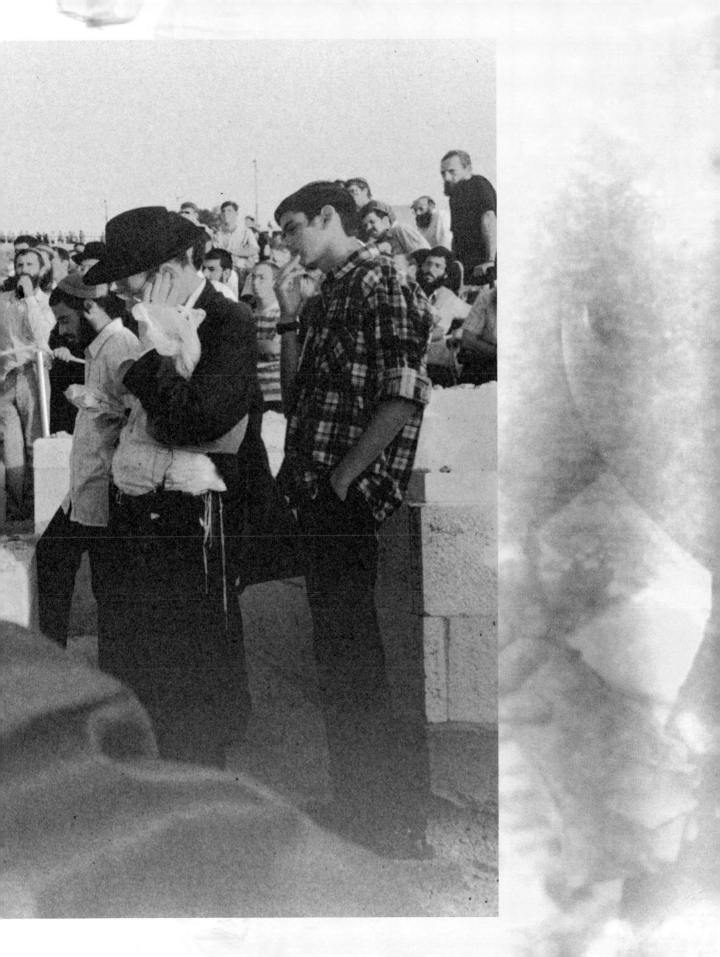

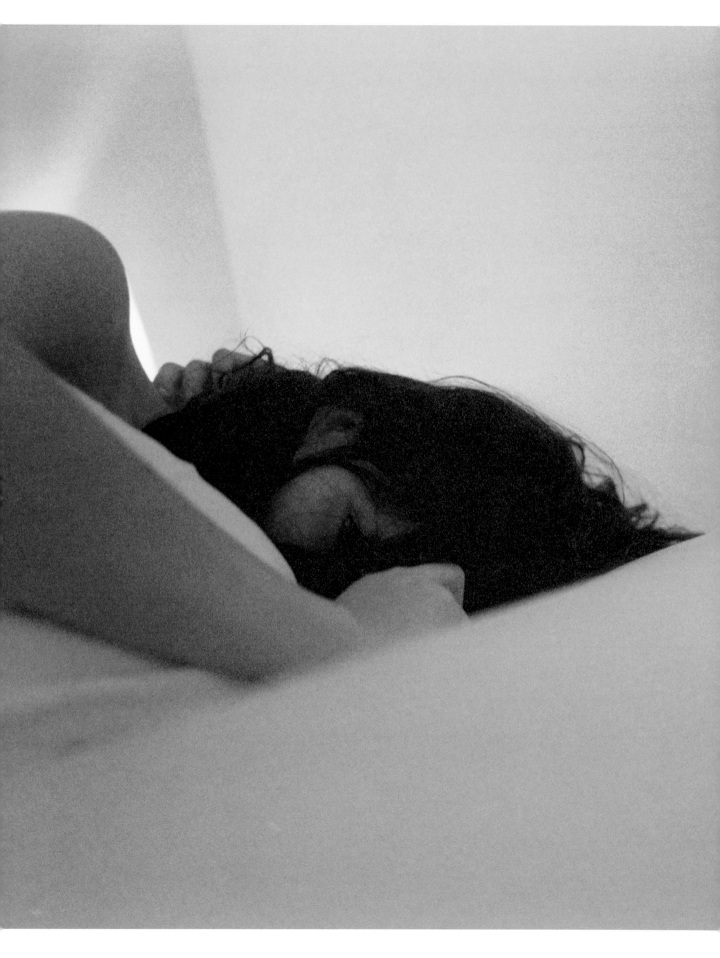

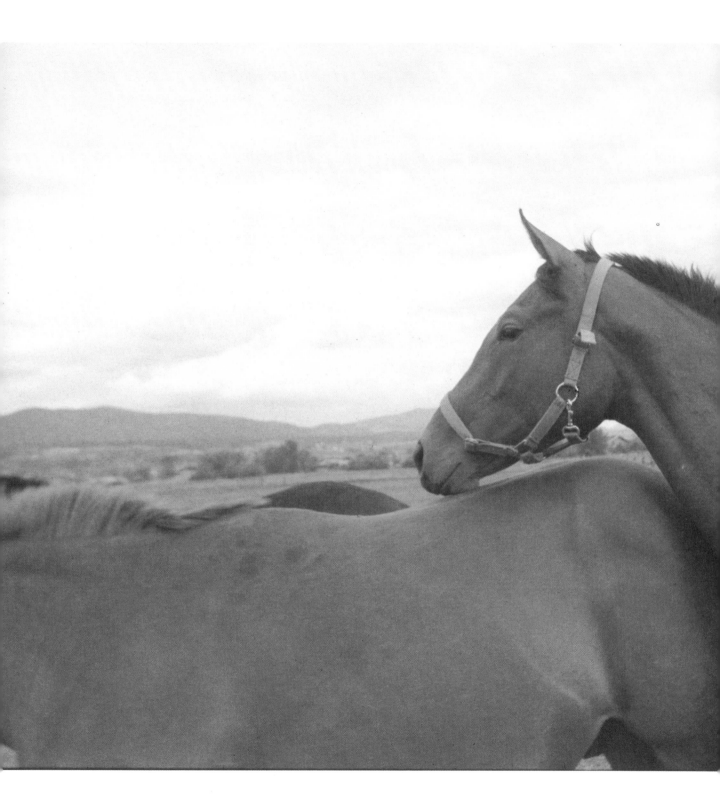

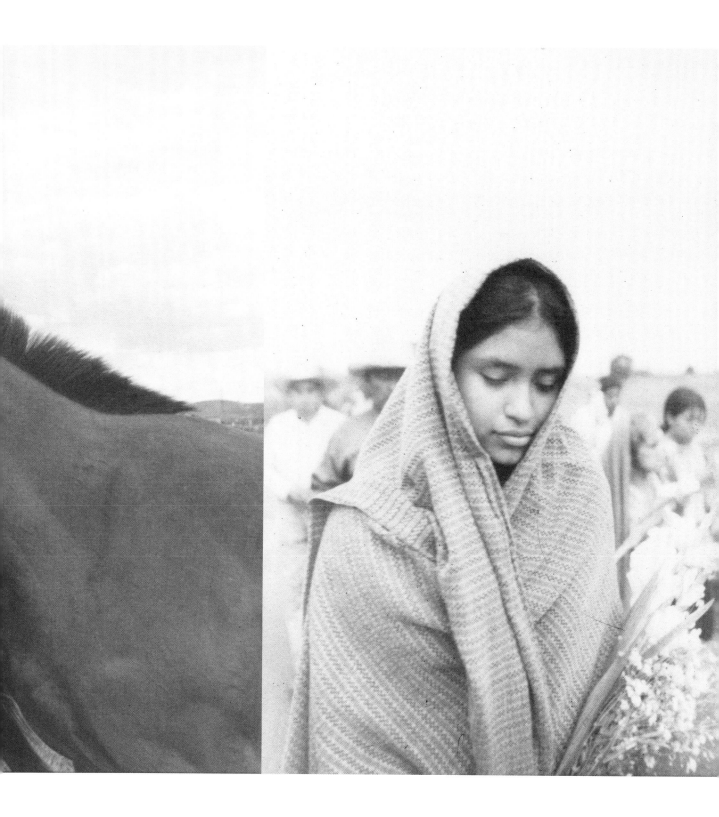

looking at this image and the next,
i can try to piece together where i was,
but not what i was doing or why i was there.

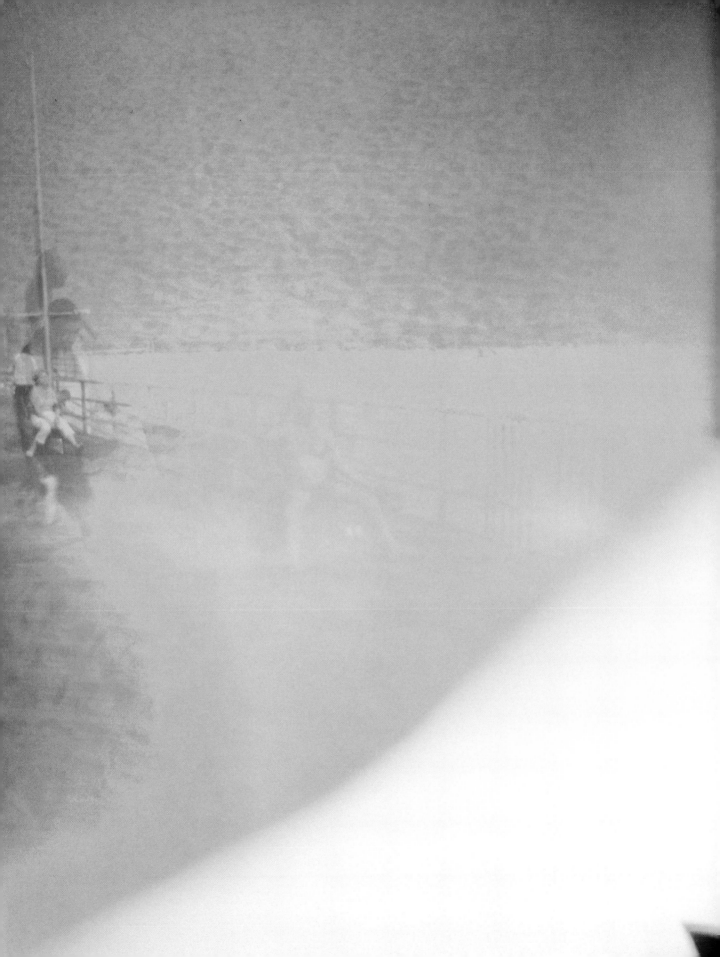

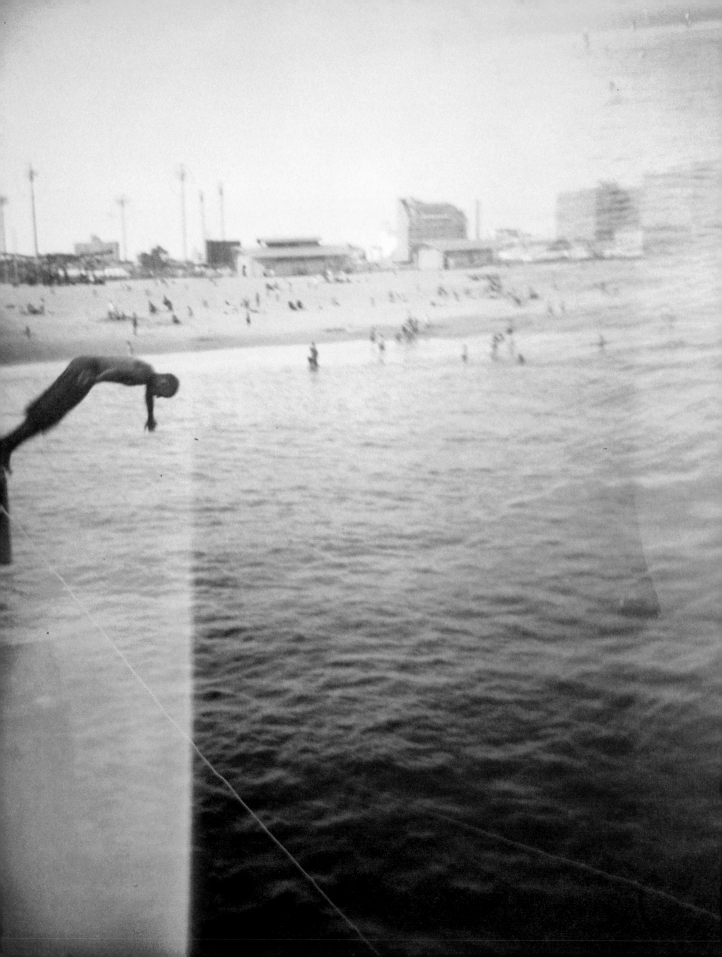

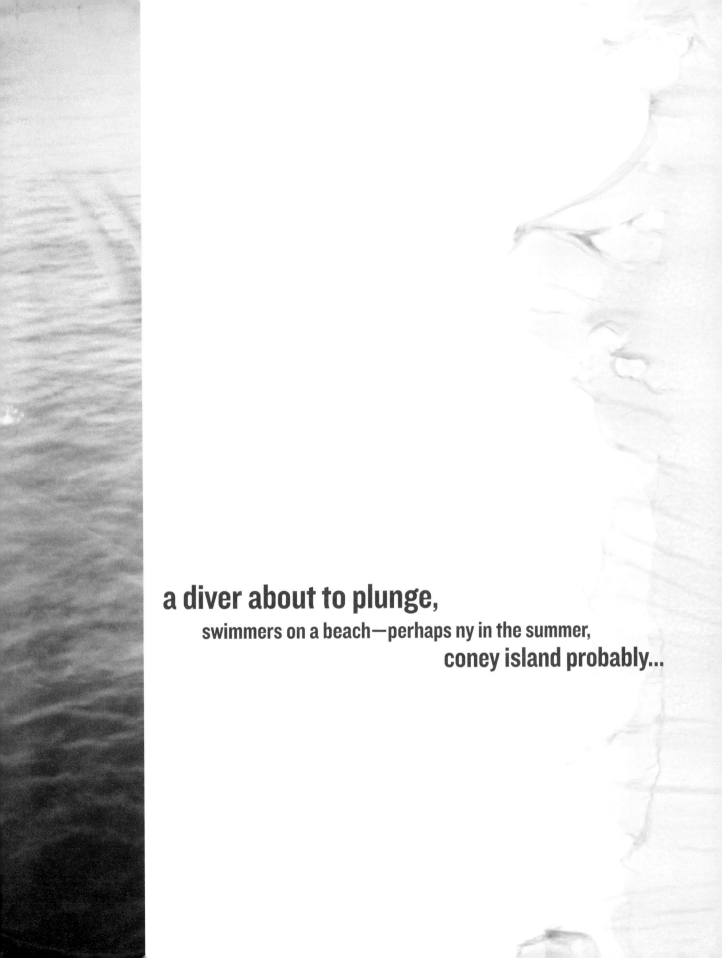

a diver about to plunge,
swimmers on a beach—perhaps ny in the summer,
coney island probably...

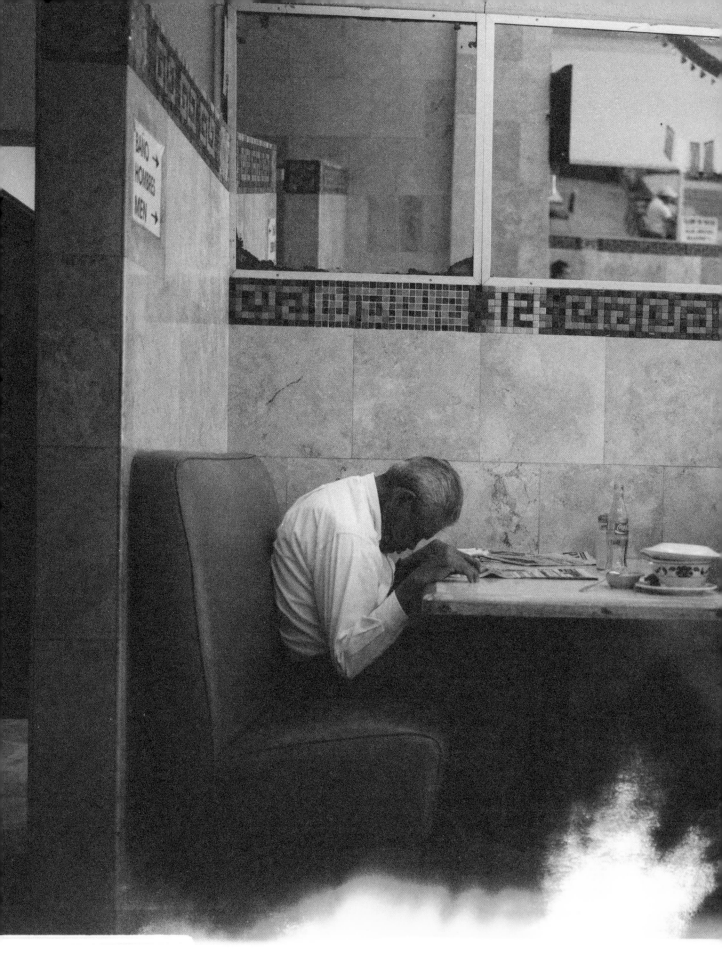

a place where there are no frontlines
 simplicity of ritual mourning,
no demarcations stating,
 "if you cross, danger awaits."
the drug war in mexico remains both loud and jarring
 but also quiet and asleep at the same time.
It's often impossible to know where the next
 "wrong step" exists. as in many places,
i come and go as i please, always able to escape
 when i feel it's too much.

and for those that
 i leave behind,
i do so knowing
 that they cannot.

AFTERWORD

I always believed that whenever I needed to remember, re-understand, and relive certain parts of my life, all I needed to do was look at my photographs. By doing so, I would instantly be transported back to that moment. I could remember the day, the hour, and even the instant the shutter was pressed. The sounds and the smells of the time would come rushing back to me with an immediacy. When I thought of developing hundreds of rolls of film that had sat dormant in various bags and drawers in my studio for the last 25 years, I was comforted to know that I would be seeing and remembering parts of my past.

The rolls were sent to a lab, developed, and scanned—a mix of the old world and the new. Not wanting to wait for the actual film to arrive, I started to download the scans. The files came into being on the screen, section by section, eventually completing themselves into an image. It was reminiscent of watching developer in action in a darkroom, where I had gotten my start as a photographer. That was the place where I had fallen in love with the magic of photography—the idea of not knowing exactly what was on the negative until seeing the print come to life. Now, sitting in front of a computer screen, it was an altered yet familiar experience.

Piece by piece, as the images materialized before me while files downloaded, I played a guessing game, trying to figure out what was portrayed and where. Colors had shifted, light had leaked, and mold had taken over on many of the images. Often it was hard to immediately discern what I was looking at. Memories came flooding back in some instances, but surprisingly, in many they didn't. I couldn't remember photographing this scene or that. I was perplexed. There were people in the images who I couldn't remember; I didn't know who they were or where the photo was taken.

One of the images that struck me most is perhaps the most universal of all the images found (image 19). Maybe it's of family, perhaps friends. I have no idea of time or place, nor who they are. This was a moment found on a roll with my family, as well as travel images. It wasn't possible to understand why they were on 2 frames mixed in with the rest. This image is representative of what exists in many of our drawers and shoeboxes—tucked away and forgotten, the undeveloped roll, containing a memory that we may or may not recognize. We all have these caption-less moments of our lives that create more of a gap than they fill.

Choosing the images to present in the book and how they should be shown was more difficult than I had originally thought it could be. The tendency of every photographer is to only show the best possible image. To correct the defects if possible via printing or Photoshop. Here I was forced to do the opposite. I couldn't correct the mistakes I made as a photographer or take away the effects of time. The end rule was letting the image live as it exists and with only helping it in post production to be able to be seen.

Whilst I am aging, my memory of my earliest photographs still ring true in my mind. I can remember the moments surrounding the work that I first photographed. Here they did not. I have come to understand that the process of shoot, develop, and edit, was actually more important than I thought, especially for the purposes of not "losing" the past. By looking at the work within a certain time period after photographing it, the memory of the image cemented in my mind. Without that process the image can become unanchored— memory that floats freely.

As I look back at this work, I feel assured in some ways that pieces of the blank pages of my past are being filled. But I will always wonder what I've forgotten and more importantly, did I say what needed to be said with the work I did.

These images take me around the world once again. Even though I don't remember each and every moment, those "lost" memories on the page remind me of what I once saw and experienced. For so many of us those moments lay in each of our own lost rolls.

INDEX

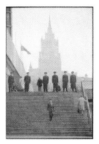

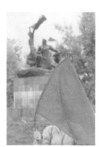

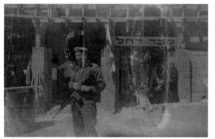

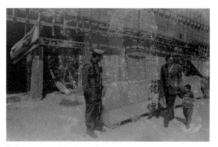

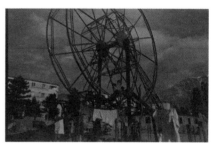

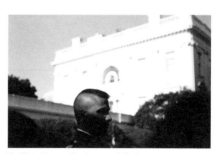

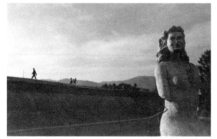

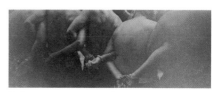

16. Andre Agassi at US Open. New York 1988

17. CBGB performance. New York, date unknown

18. Photographer Alexandra Boulat. Spain 2001

19. Location and date unknown

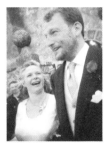
20. Wedding of friends. Spain 2001

21. Scene of a war crime. Bijeljina, Bosnia 2004

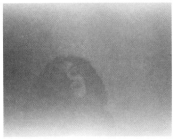
22. Girlfriend. Location and date unknown

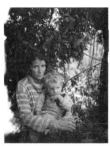
23. Displaced Kosovars living in mountains. Kosovo 1998

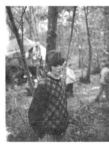
24. Displaced Kosovars living in mountains. Kosovo 1998

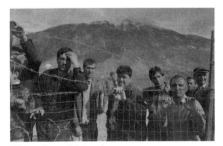
25. Location and date unknown

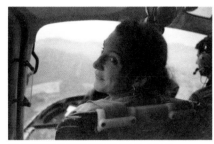
26. War Correspondent Marie Colvin. Kosovo. date unknown

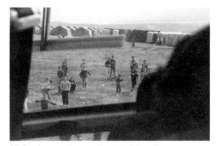
27. Displacement camp. Kosovo, date unknown

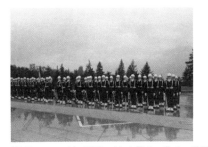
28. Honor guard for US President Clinton. Turkey 1999

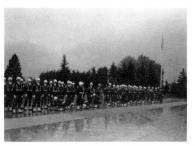
29. Honor guard for US President Clinton. Turkey 1999

30. Srebrenica, Bosnia 1996

INDEX

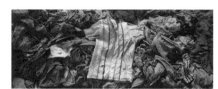

31. Genocide Memorial. Kigali, Rwanda 2009

32. Genocide Memorial. Kigali, Rwanda 2009

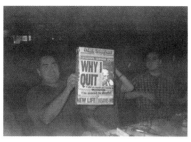

33. Friends. Location and date unknown

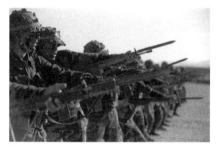

34. Location and date unknown

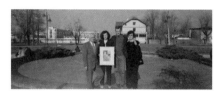

35. The Fako family. Illidza, Bosnia 2004

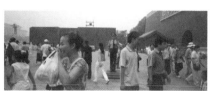

36. Tiananmen Square. Beijing, China 2004

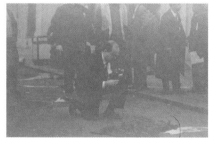

37. Location and date unknown

38. Thailand 2012

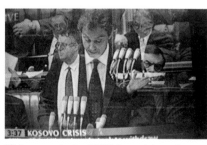

39. News reports about NATO Kosovo intervention. Kukes, Albania 1999

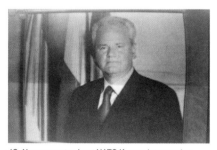

40. News reports about NATO Kosovo intervention. Kukes, Albania 1999

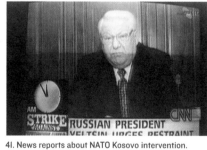

41. News reports about NATO Kosovo intervention. Kukes, Albania 1999

42. News reports about NATO Kosovo intervention. Kukes, Albania 1999

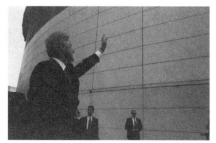

43. US President Bill Clinton at ceremony. Germany 1998

44. US President Bill Clinton at ceremony. Germany 1998

45. US President Bill Clinton at ceremony. Germany 1998

46. US President Bill Clinton at ceremony. Germany 1998

47. US President Bill Clinton at ceremony. Germany 1998

48. Sarajevo, Bosnia 2004

49. NYPD. Location and date unknown.

50. NY Mayor Rudy Giuliani. Location and date unknown.

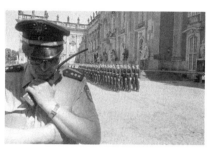
51. Honor guard for US President Bill Clinton. Germany 1998

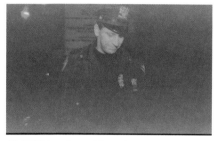
52. US President Bill Clinton, Hillary and Chelsea Clinton. Turkey 1999

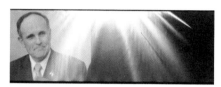
53. US President Bill Clinton, Hillary and Chelsea Clinton. Turkey 1999

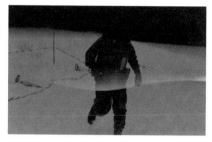
54. US troops arrive to enforce Dayton Peace agreement. Tuzla, Bosnia 1995

55. US troops arrive to enforce Dayton Peace agreement. Tuzla, Bosnia 1995

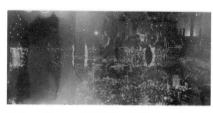
56. Funeral for Israeli PM Yitzhak Rabin. Jerusalem, Israel 1995

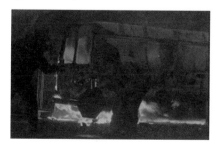
57. Protests. Northern Ireland 2005

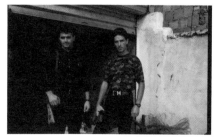
58. Gunrunners for Kosovo war. Albania 1999

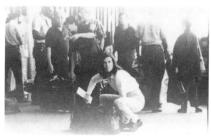
59. Location and date unknown

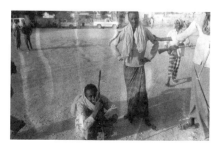
60. Armed militia. Somalia 1992

INDEX

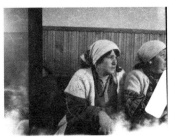

61. Funeral. Kosovo 1998

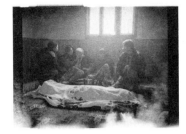

62. Funeral. Kosovo 1998

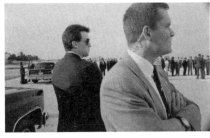

63. US Secret Service await Air Force One. Location and date unknown

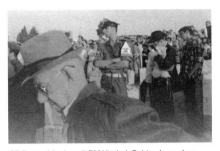

64. Air Force One arrival. Location and date unknown

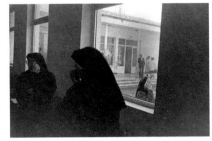

65. Location and date unknown

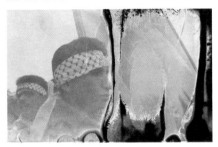

66. Pro Arafat rally. West Bank, date unknown

67. Funeral for Israeli PM Yitzhak Rabin. Jerusalem, Israel 1995

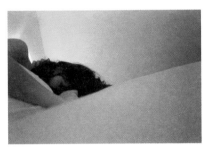

68. Girlfriend. Location and date unknown

69. Bosnia 2000

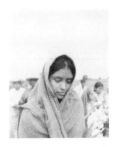

70. Actor on commercial film set. Mexico 2002

71. Location and date unknown

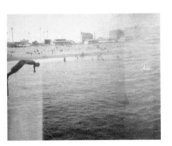

72. Location and date unknown

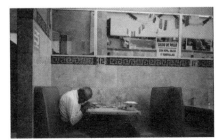

73. Juarez, Mexico 2012

74. Brooklyn, NY, date unknown

Ron Haviv

Ron Haviv is an Emmy nominated, award-winning photojournalist and co-founder of the photo agency *VII*, dedicated to documenting conflict and raising awareness about human rights issues around the globe.

In the last three decades, Haviv has covered more than twenty-five conflicts and worked in over one hundred countries. He has published three critically-acclaimed collections of photography, and his work has been featured in numerous museums and galleries, including the *Louvre, the United Nations, and the Council on Foreign Relations*. Haviv's photographs are in the collections at *The Houston Museum of Fine Arts* and *George Eastman House* amongst others as well as numerous private collections.

Haviv has produced an unflinching record of the injustices of war and his photography has had singular impact. His work in the Balkans, which spanned over a decade of conflict, was used as evidence to indict and convict war criminals at the international tribunal in The Hague. President H.W. George Bush cited Haviv's chilling photographs documenting paramilitary violence in Panama as one of the reasons for the 1989 American intervention.

His film work has appeared on PBS's *Need to Know* and *Frontline* as well as *NBC Nightly News* and *ABC World News Tonight*. He has directed short films for *ESPN, People Magazine, Doctors Without Borders, Asia Society*, and *American Photography*. Haviv's music videos have been on the *MTV Europe* and *Sol Musica* channels in Spain.

His first photography book, *Blood and Honey: A Balkan War Journal*, was called "One of the best non-fiction books of the year," by *The Los Angeles Times* and "A chilling but vastly important record of a people's suffering," by Newsweek. His two other monographs are *Afghanistan: The Road to Kabul* and *Haiti: 12 January 2010*.

Haviv has helped create multi-platform projects for Doctors Without Borders' *DR Congo: The Forgotten War* and *Starved for Attention*; UNICEF's *Child Alert for Darfur* and Sri Lanka; and the International Committee of the Red Cross's *World at War*.

Haviv is the central character in six documentary films, including National Geographic Explorer's *Freelance in a World of Risk*, in which he speaks about the dangers of combat photography, including his numerous detentions and close calls. He has provided expert analysis and commentary on *ABC World News, BBC, CNN, NPR, MSNBC, NBC Nightly News, Good Morning America*, and *The Charlie Rose Show*.

About this Book

W.M. "Bill" Hunt is a photography collector, dealer, writer, teacher, judge, curator, fundraiser, and consultant... everything but photographer. He loves photography. It changed his life; it gave him one.

Robert Peacock, project editor, is a content strategist, editor, and producer, specializing in photography and visual storytelling. He has also authored several collections, including *Light of the Spirit: Portraits of Southern Outsider Artists* (University Press, Mississippi), *Sleep: Bedtime Reading*, with Roger Gorman (Universe/Rizzoli), and *Paradise Garden: A Trip Through Howard Finster's Visionary World* (Chronicle Books).

Dr. Lauren Walsh is a professor and writer. She teaches visual culture studies at NYU and The New School in New York City. She is co-editor of *The Future of Text and Image* (2012), and has published with the *Los Angeles Review of Books*, the "About Images" series of Nomadikon: The Bergen Center of Visual Culture, *Photography and Culture*, and the *Romanic Review*, among others. She holds a PhD from Columbia University.

Special thanks to Dan Milnor and Eileen Gittins for their curiosity about the images on the lost rolls and to Blurb, the creative self-publishing platform, that made this book possible.

Copyright © Ron Haviv 2015, all rights reserved.
Essays copyright by the authors as attributed.
ISBN: 978-1-32-099884-0

Design by Roger Gorman/reinerdesignconsultants.com
Image and color consultation by Becci Manson/thepostoffice.nyc